GOLF IN
FLORIDA
1886–1950

Holly Hill Historic Society
Museum & Education Center
PO Box 250704 1066 Ridgewood Ave
Holly Hill. Florida 32125

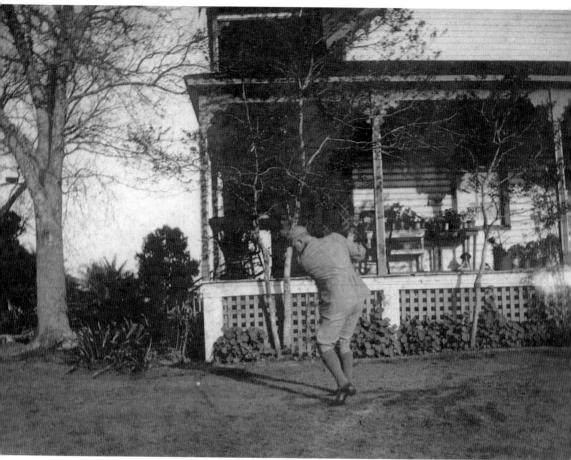

J. Hamilton Gillespie tees off on his two-hole course, located immediately in front of his home in Sarasota in 1896. (Courtesy of the Sarasota County Department of Historical Resources.)

FRONT COVER: New York Yankee baseball great Babe Ruth and Gov. Al Smith pose for a photograph at the Miami Biltmore during a pro-am event preceding the 1931 Miami Four-Ball Tournament. (Courtesy of the Historical Association of Southern Florida.)

COVER BACKGROUND: The Temple Terrace Country Club attracted wealthy members who welcomed the opportunity to play golf among the expanding orange groves. The many tournaments sponsored by the club attracted large galleries and prospective buyers. Notice at the left side of the photograph the large (and not air-conditioned) bus, which was used to transport prospective members on a tour of the development. (Courtesy of the Burgert Brothers Collection, Tampa-Hillsborough Public Library.)

BACK COVER: From left to right, Johnny Farrell, Gene Sarazen, Leo Diegel, an unidentified golfer, and Walter Hagen pose for a photograph prior to the Miami Open in 1930 at the Miami Country Club. (Courtesy of the Historical Association of Southern Florida.)

GOLF IN FLORIDA
1886–1950

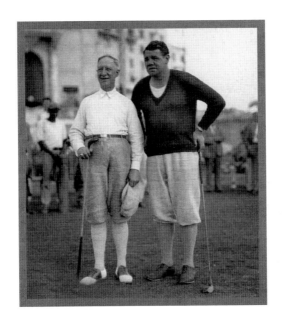

Richard Moorhead and Nick Wynne

ARCADIA
PUBLISHING

Published by Arcadia Publishing
Charleston SC, Chicago IL, Portsmouth NH, San Francisco CA

Printed in the United States of America

Library of Congress Catalog Card Number: 2008938224

For all general information contact Arcadia Publishing at:
Telephone 843-853-2070
Fax 843-853-0044
E-mail sales@arcadiapublishing.com
For customer service and orders:
Toll-Free 1-888-313-2665

Visit us on the Internet at www.arcadiapublishing.com

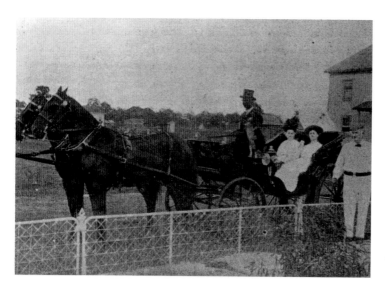

After a nine-hole municipal course was built in Sarasota, J. Hamilton Gillespie journeyed between his home and the course in a liveried carriage. Note the formal dress of his family members, who were sharing his love of golf as spectators. (Courtesy of the Sarasota County Department of Historical Resources.)

CONTENTS

ACKNOWLEDGMENTS

Many individuals were very instrumental in helping to create this book, and we are thankful that they were willing to share their knowledge and open their collections to us. People who gave of their time and access to photographic collections, maps, and other memorabilia for the purpose of assisting our efforts are greatly appreciated.

The authors wish to express appreciation for the generous support given by the following historians, golfers, and just plain people who love history in general—especially Florida golf history: the Florida Historical Society and executive director Karen Bednarski, Golf Collector's Society and executive director Michael Fay, Donald Ross Society, Kenneth L. Hopkins, Christopher Lick, Gertrude F. Laframboise, Douglas Michael Nix, Brendon Elliott, Robert G. Ley Jr., Edward J. Shaughnessy, Steve Kronen, Johnny Woodhouse, Jim Garrison, Kelly R. Miller, Brady Rackley, Anza and Robert Bast, Clayton Bishop, Tom Hampton, Walter Rowe, April Anderson, Patrick Ahearn, Marianne Popkins, Jason Epstein, Randy Weber, Chris Jett, Renee Trudeau, John Shipley, Dawn Hugh, Rebecca A. Smith, Sam Boldrick, Dan Newman, Joe Neely, Rich Lamb, Joe Knetsch, Robert Duke, Theodore B. VanItallie, Susan Carter, Jim Slattery, Thomas S. Stewart, Brock Witmyer, Ernie Anlauf, Ron Garl, Bobby Weed, Dan Wexler, Rodney Reifsnider, Chuck Eade, Terry Decker, Brian Lake, Edward Buckey, Ben Brotemarkle, Harold Cardwell, Robert Snyder, Sidney Matthew, Randy Mosely, Scott B. Edwards, Truman Wilson, Scott Hampton, Downing Gray, Pepper Peete, Calvin Peete, Scott Hampton, Rebecca B. Saunders, Tommy Lyman, Frances Yeo, John Elkins, Jamie Pate, Steve Dana, Jim Howard, Carl (Sandy) Dann III, Claude W. Bass III, Charles Hendley, Hendy Hilton-Green, Chris Blocker, Lynne Robertson, William Clifton, Carolyn Prince, Dave Hanson, Fred Seely, Frank Stephens, Ryan Taylor, Harriett Rust, Holly Beasley, Charles A. Tingley, Nancy Sikes-Kline, Taryn Rodriquez-Boette, John S. Wait, Brian Siplo, Carter Quina, Lester Smith, John Butler, Mark Vandyck, Vernon Peeples, James R. Brand, Andrew Nash, Audrey Moriarty, Patty Moran, Bruce McBride, Charles Stone, Sandra Eriksson, Bill Berl, Gavin Darbyshire, Daren A. King, Burton Langley, Mark Dunn, Jason Fedorka, Chris Klinck, Robert Kirby, Tom Haskell, John Viera, Donna Beucher Line, Tom Line, Bob Beucher, Peggy Beucher Clark, Bill Dreggors, Jim Hafner, Lanie Hamel, Mark Cubbedge, Ann Shank, Ray Grady, John Von Preysing, Jeff LaHurd, Rick Reed, Jim Cusick, Tana Porter, Debbie Hobbs, Merrilyn C. Rathburn, Joan Mickelson, Dorothy Patterson, Mark McDavitt, Donald Gaby, Debi Murray, Jerome Richardson, Frank Hampton, Frank Stevens, Marsha Dean Phelts, William Mayturn, Ralph Hunter, Eddie Herman, Bob Cook, Susan Thurlow, Jackie Ryden, Jerry Chicone, Greg Vandergrift, Jack Pate, Kim Kyle, John Falcone, Don Goodall, Tony Mitchell, Lindsey Williams, Eleanor Wilbanks, Dick Heard, Tom Rae, Luke Cunningham, Lindsay Bennison, Katie Kellett, Lynn Ruggieri, and last, but certainly not least, our wives Sandy Moorhead and Debra Wynne.

INTRODUCTION

If you are looking to learn how to make a crisp three-metal shot of some 240 yards from a hanging lie, this is not the book for you. If you want to refine your technique for hitting a 55-yard bunker explosion shot from a buried lie in the sand, this is not the book for you. However, if you are a golfer who loves history, a historian who loves golf, or just a plain old "brown wrapper" historian, you will thoroughly enjoy this book dedicated to golf history in Florida from 1886 to 1950. Some of the best classic golf courses were built in the Sunshine State during this "Golden Era" of course design. In 1930, the state of Florida had over 230 golf courses from Jacksonville to Key West on the East Coast, from Pensacola to Naples on the West Coast, throughout the panhandle, and in the center of the peninsula. Some 73 of these classic courses are still in existence and playable today. There are 37 private courses and 35 public/resort courses remaining from the golden era in Florida, in addition to another 1,200 courses that have been built since 1940.

The evolution of golf into the most widely played sport in Florida—and the United States—was a process that started slowly, but it was one that rapidly gained speed as American society entered into the industrial age and the newly emerging middle class, suddenly enriched with disposable income, sought to mimic the activities of the very rich, such as the Vanderbilts, Carnegies, Flaglers, Plants, Astors, Cabots, and other families of long-standing social prominence in America. Although the lavish lifestyles of the superrich—which included the game of golf—filled the pages of the newspapers and magazines of the period, the middle class provided the numbers necessary to change the game from a "quaint Scottish pastime" to a major sport.

This book is also about the men who pioneered golf course design in Florida, including Col. John Hamilton Gillespie, the Scottish immigrant who is widely recognized as building the very first two golf holes in the state in what is today downtown Sarasota. Gillespie designed the first golf courses in Sarasota, Belleair, Tampa, Kissimmee, Winter Haven, and Havana, Cuba. Later professional designers such as Alex Findlay, John Duncan Dunn, Donald J. Ross, Arthur W. Tillinghast, William B. Langford, Seth Raynor, Herb Strong, Wayne Stiles, John Van Kleek, and William S. Flynn were instrumental in setting the standards and establishing parameters for golf course design, which were soon copied by scores of less talented designers.

Finally, this book shows the evolution of some of these courses into venues of the first rank for regional, national, and international tournaments and matches. It is also about how various personalities, such as Britain's Harry Vardon along with Americans like Walter Hagen, Bobby Jones, Johnny Farrell, Ky Laffoon, Babe Didrikson Zaharias, Patty Berg, and others, popularized golf in Florida by playing such courses, promoting real estate deals, and by focusing attention on the game itself.

Throughout the book, historical photographs are used to show the major courses and individuals that contributed to the growth of the game in the state. This has been a labor of love for us as we have visited with most of the historical societies in the state collecting vintage photographs and

newspaper articles and reviewing countless periodicals and books. We have a collection of over 2,000 golf photographs and some will appear in other publications yet to be released.

We hope you, the reader, will understand our passion for the game, recognize the hours spent putting this book together as worthwhile, and, finally, enjoy the book as much as we did writing it.

—Richard Moorhead and Nick Wynne

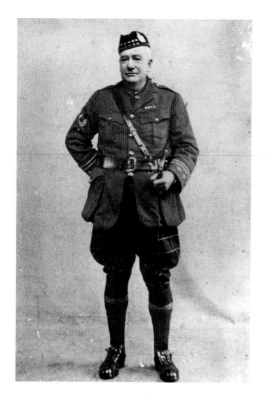

J. Hamilton Gillespie, who came to Florida to oversee his father's development project, is credited with building the first two golf holes in the Sunshine State. (Courtesy of the Sarasota County Department of Historical Resources.)

J. Hamilton Gillespie had a distinguished military career before he came to Florida and served with British forces during World War I. (Courtesy of the Sarasota County Department of Historical Resources.)

1

THE BEGINNING

1 8 8 6 — 1 9 2 0

Many enthusiasts agree that the game of golf was introduced to Americans when a Scottish immigrant, Col. J. Hamilton Gillespie, built a private course at his home in Sarasota in 1886. With only two greens and a fairway, the course was modest by European standards, but it gave the colonel an opportunity to practice the game he had learned as a youth in his native Scotland. Gillespie had to play a solitary game because there were fewer than a dozen other golfers in the United States and none in the Sarasota area. Despite the scarcity of golfers in 1886, Gillespie and other golfers in the northeast had begun to attract new aficionados to the game and slowly—ever so slowly—converted a number of adherents to the game in Sarasota; so many, in fact, that they decided that an expanded course was needed. In 1905, a nine-hole course was plotted and constructed under his direction. Despite the growing number of golfers in the area, Gillespie owned the course until 1910, when he sold it to the Sarasota Golf Holding Company, which operated it until 1924. Golf in the area moved away from being a private game on a private course to being a public activity—although generally restricted to the wealthier residents of the town—with a corporate identity. The course was sold to Charles Ringling in 1924.

Recognized as an expert on the game, Gillespie wrote columns for *Golfer's Magazine* and *New York Golf*. Drawing on his experiences in the United States and Scotland, his writings attracted the attention of Henry B. Plant, an early golf enthusiast, who hired Gillespie in 1897 to build a six-hole course on the front lawn of his Tampa Bay Hotel. Soon every Plant hotel featured a course, and Plant's company promoted them as a means of attracting winter visitors. Plant hotels in Tampa, Kissimmee, Port Tampa, Belleair, and Naples had courses designed and built by Colonel Gillespie.

In 1898, Plant's cross-state rival, Henry Flagler, had also taken note of the estimated 150,000 golfers in the United States, and he wanted as many of them as possible to make reservations at his hotels. He hired Scotsman Alexander H. Findlay to design and build five courses for his Florida East Coast hotels, which were soon consolidated into the Florida East Coast Golf Club. Findlay became the golfer-in-chief for all of Flagler's hotels, and although other experts would occasionally be hired to design for specific venues, he remained in charge of maintaining them and in providing such services as professional instruction for new golfers or those who wanted to improve their game, tournaments to bring professionals to the different courses, competitions between amateur golfers, and tournaments that pitted professionals against a field of amateurs.

In Atlantic Beach, St. Augustine, Ormond Beach, Palm Beach, and Miami, the exclusive resorts operated by Flagler interests featured pictures of men and women enjoying golf on courses designed by Alexander H. Findlay, one of the leading golf architects of the period.

The success of Plant and Flagler in using golf as a means of attracting visitors to their hotels did not go unnoticed by the scores of developers who intended to take advantage of the cheap land and great climate of Florida. Men like George Merrick, Carl Fisher, D. P. "Doc" Davis, and other smaller operators such as Orlando real estate developer Carl Dann Sr., bought large tracts of land for their "planned communities," and most of these were clustered around a golf course. Golf's increasing popularity can be traced to the efforts of these promoters, who used the game as a lure to bring Americans with significant disposable income to the Sunshine State. Noted golfers and architects were recruited to create courses that would challenge amateur and professional golfers. With each new course, real estate sales soared, and even more courses were built.

By the end of the first decade of the 1900s, golf courses and houses with Mediterranean designs were hallmarks of the state's development boom. Millions of pieces of printed matter were mailed in bulk to Americans, and virtually every newspaper and magazine in the United States ran at least one advertisement with golfers prominently featured.

Despite its humble beginnings with Gillespie's course in Sarasota, golf had arrived in the Sunshine State. Since 1895, more than 1,400 courses have been built in Florida alone, and new courses are being opened each year. Golf far surpasses any other sport in popularity, but marketing the game to new residents of the state has not changed since the earliest days of the 1900s. Developers still use their designer courses to sell real estate to those who, having acquired some modicum of wealth (or credit), equate playing golf with social and financial success.

Real estate developers matched the hoteliers in their promotion of golf as a sales tool to attract buyers. Donald J. Ross, Arthur W. Tillinghast, Tom Bendelow, and William Boice Langford, noted course architects of the early 1900s, were employed to design courses that would be unique to play. Promoters proudly included the names of the designers in their advertisements, confident that knowledgeable golfers would choose to play courses created by the "best" architects.

Golf is an expensive sport to play, and the cost of participating—equipment, green fees, appropriately fashionable attire, and club membership fees—can easily run into the thousands of dollars each year. Early on, promoters recognized that additional profits could be made by providing pro shops that featured the latest golf fashions and equipment. Even more profits came from the inclusion of a teaching professional on the staff of the courses where novices could receive the best instruction from individuals who were recognized experts. Modern course operations continue to use pros and pro shops as ways to generate revenue.

Virtually every gated community or large-scale development in Florida prides itself on having a course that is open to members only. Courses have become venues where making business contacts or deals are as important as achieving a low score. And that is an important element that adds to the popularity of the game.

Many municipal courses of note have been built since the mid-1930s as a direct result of Pres. Franklin Delano Roosevelt's New Deal work programs. These courses are frequented by both novice and skilled players who are aspiring to add golf to their list of endeavors and who negotiate their own deals—although usually on a much smaller scale—on the greens and fairways. For many Americans of all social classes, golf is much more than simple recreation; it is also a business essential.

One thing is certain. Since its introduction to the Sunshine State, the number of golfers, like the number of courses, continues to grow. From youngsters below the age of 10 to aficionados in their 90s, interest in the sport is widespread and intense.

The area around Sarasota was still a primeval wilderness when Gillespie arrived in 1886. Gradually the masses of palms, palmettos, and scrub oaks were cleared for building plots, and homes were erected. (Courtesy of the Sarasota County Department of Historical Resources.)

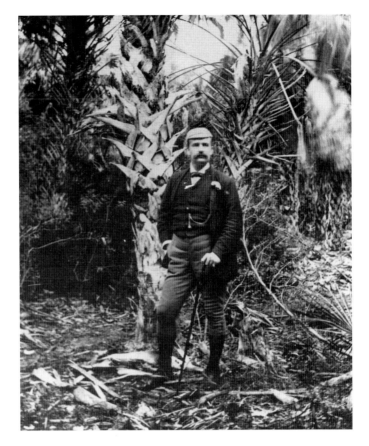

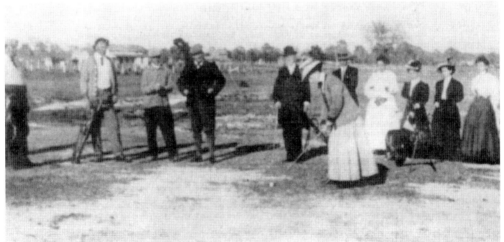

Golf came to Sarasota in 1886, when J. Hamilton Gillespie (wearing a cap with hands in his pockets) built the first two golf holes in Florida near his home. Golf was (and continues to be) a sport enjoyed by males and females. Here Blanche Gillespie plays golf on the nine-hole golf course built in the center of modern-day Sarasota. (Courtesy of the Sarasota County Department of Historical Resources.)

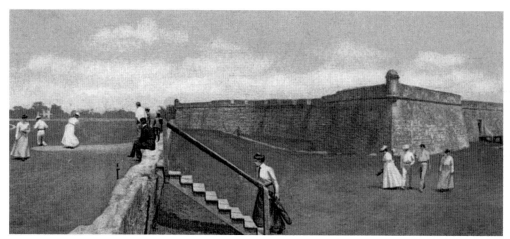

The small resort village of St. Augustine had two nine-hole golf courses before the beginning of the 20th century. Guests at Henry Flagler's various hotels would play the different courses to find one that suited their skill level. Here male and female golfers around 1902 climb a ladder to reach the tee located immediately in front of the picturesque and historical Castillo de San Marcos, a coquina fort built by the Spanish in the 1670s. (Courtesy of the Moorhead Collection.)

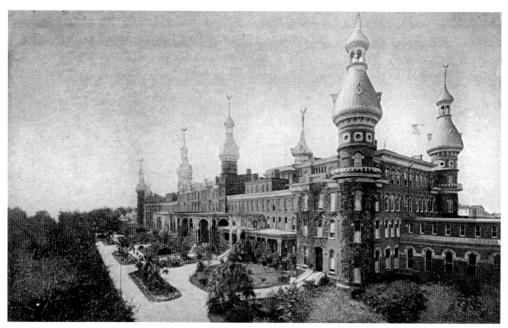

Henry Bradley Plant's Tampa Bay Hotel was an exotic combination of Persian and Moorish architecture built of red bricks that featured high arches in the interior hallways and spacious verandas in front and back. When it was built in the early 1890s, guests could hunt wild birds, play a round of golf, or stroll through luxurious gardens—all on the front lawn. The Tampa Bay Hotel served as the headquarters for the American army on its way to fight in the Spanish-American War of 1898. (Courtesy of the Moorhead Collection.)

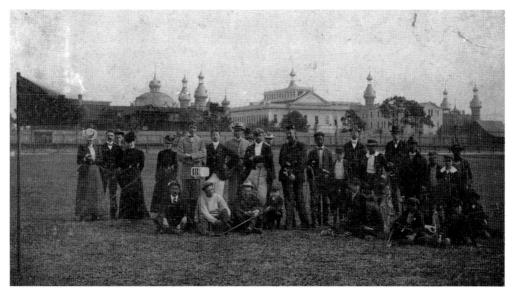

J. Hamilton Gillespie (center with Glengarry cap) and a group of golfers pose for this photograph on the 18th hole of the Tampa Bay Hotel golf course. The oriental spires of Henry Plant's showplace hotel can be seen in the distance. The enormous white building immediately behind the group is the hotel's casino, a place where stage entertainments, large banquets, and dances were held. (Courtesy of the Moorhead Collection.)

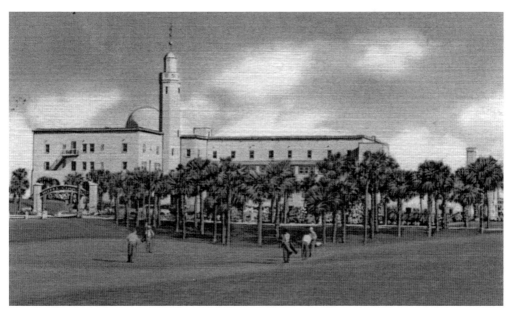

Hotel Coquina, pictured around 1900, was one of several fine hotels surrounding the Alexander Findlay–designed Ormond Golf Links course, owned by Henry Flagler's Florida East Coast Railway Company. (Courtesy of the Moorhead Collection.)

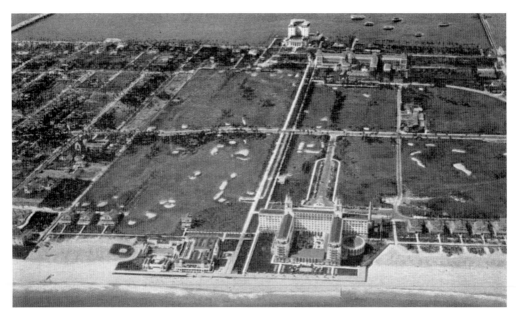

Fabulous and wealthy Palm Beach was the creation of Henry Flagler. Flagler's spectacular home, Whitehall, and his two hotels, the Royal Poinciana and The Breakers, were on the periphery of the 18-hole golf course that dominated the social life of the island community. This is the oldest 18-hole golf course in the state of Florida and has been in continuous play since 1895. (Courtesy of the Moorhead Collection.)

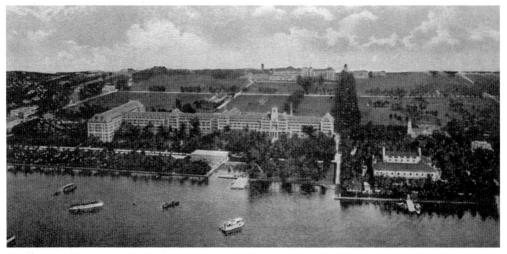

Henry Flagler's hotel and railroad empires stretched the length of the Sunshine State's east coast from Atlantic Beach to Key West. This photograph shows two of his most opulent hotels—the Royal Poinciana and The Breakers—which made Palm Beach the winter vacation choice of thousands of wealthy Americans and Europeans during the late 1800s and early 1900s. Even today, the well-to-do make The Breakers the hotel of choice in Palm Beach. (Courtesy of the Moorhead Collection.)

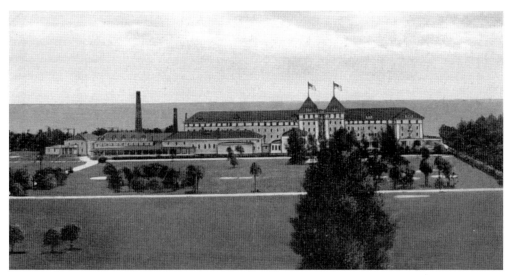

The Breakers, Henry Flagler's premier hotel in Palm Beach, faced the Atlantic Ocean but provided visitors an opportunity to "hit the fairways" immediately out the front entrance. Advertised as the place "where Springtime spends the Winter," The Breakers remains a popular golfing destination. (Courtesy of the Moorhead Collection.)

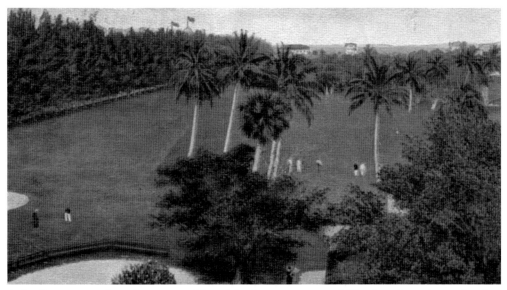

A bird's-eye view from Poinciana Chapel looking east toward The Breakers shows the first 18-hole golf course in Florida, which is still operating on the same plot of land. (Courtesy of the Moorhead Collection.)

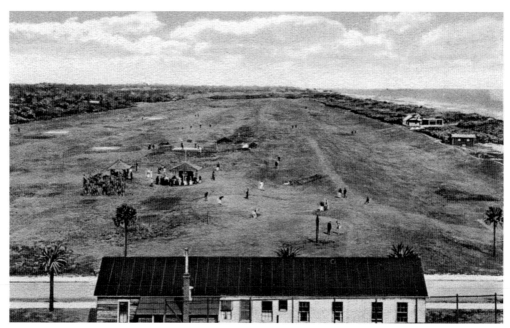

Ormond Golf Links was one of the first golf courses built on the east coast of Florida by Henry Flagler in 1898. This was one of four golf courses on the east coast of Florida designed by Alexander Findlay for the Florida East Coast Railway Company. Flagler also had a hotel and golf course in Nassau, Bahamas. Findlay built the courses in and around the sand dunes in order to give the course the "Scottish links" look. (Courtesy of the Moorhead Collection.)

The Qui-Si-Sana Hotel in Green Cove Springs featured a world-class golf course among the amenities offered to its guests in the late 1800s. (Courtesy of the Moorhead Collection.)

THE BEGINNING: 1886–1920

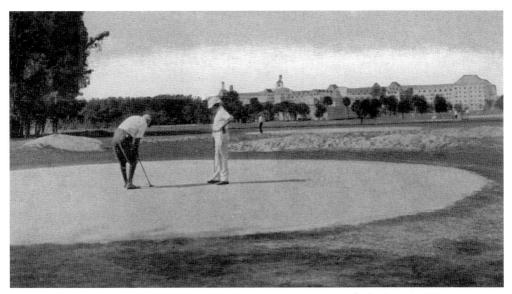

One of the oiled sand greens on the Palm Beach Golf Club adjoined what would later become The Breakers hotel. (Courtesy of the Moorhead Collection.)

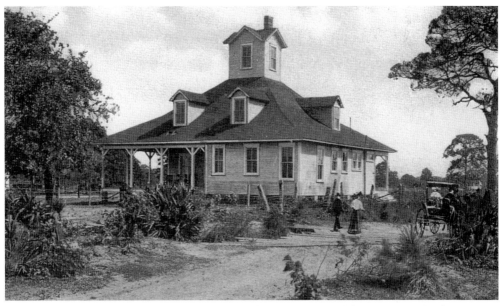

This is the Sarasota Golf Club clubhouse in the downtown area of the city in 1905. This was one of the earliest golf courses in Florida and was built by Scotsman J. Hamilton Gillespie, the father of golf in Florida. (Courtesy of the Moorhead Collection.)

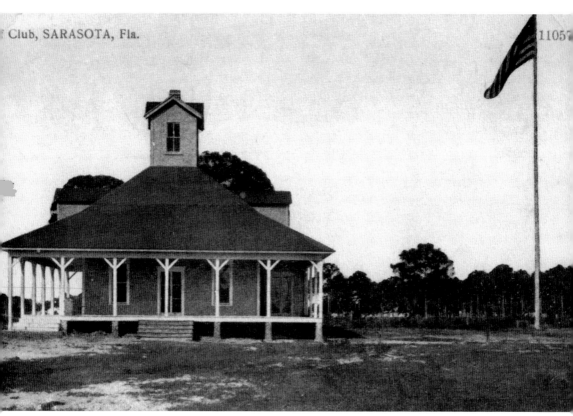

The front of the first clubhouse for the Sarasota Golf Club, which opened in 1905, is shown here. (Courtesy of the Sarasota County Department of Historical Resources.)

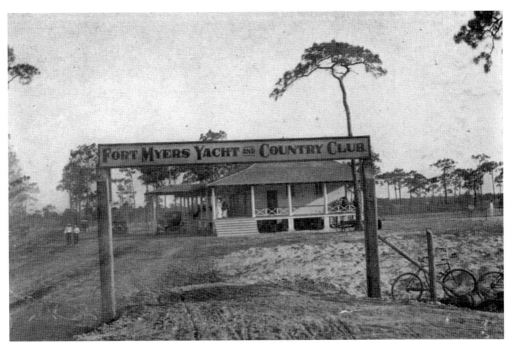

In 1908, a very rudimentary golf course was developed in Fort Myers on a sandy plot of scrubby land just east of the town. It took about an hour by horse and buggy to reach the Fort Myers Yacht and Country Club clubhouse from downtown. (Courtesy of the Fort Myers Historical Society.)

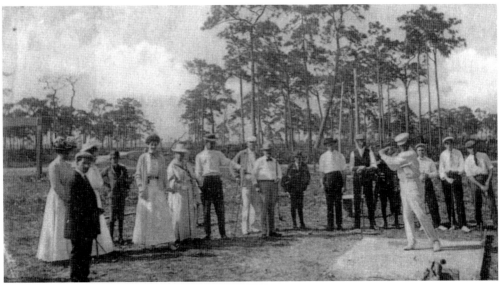

This gallery of spectators is watching the player's tee shot at the Fort Myers Yacht and Country Club links in 1909. Note the sand tee box. Players fashioned a tee from a box of sand, positioned the ball atop the small sand mound, and hoped for a smooth stroke on the ball. (Courtesy of the Fort Myers Historical Society.)

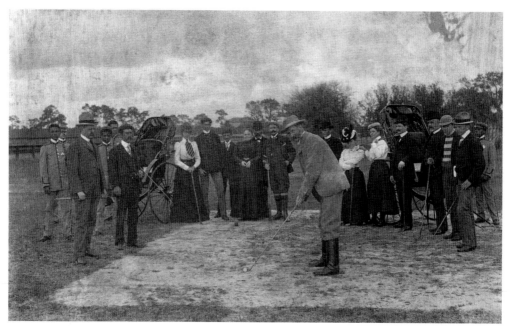

Like most wealthy Americans, Henry Bradley Plant was captivated by the game of golf, but few of his contemporaries owned their own course. Plant owned several of them. In this 1898 photograph, Plant tees off on the Belleview Hotel course in Belleair. J. Hamilton Gillespie, who had designed the course for Plant, is standing to his immediate left. (Courtesy of the Moorhead Collection.)

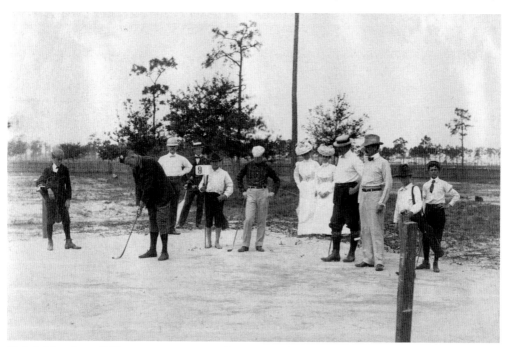

Col. J. Hamilton Gillespie putts on a sand green on the course he designed for Henry Plant's Tampa Bay Hotel. (Courtesy of the Moorhead Collection.)

THE BEGINNING: 1886–1920

The membership roster for the Gulf Stream Golf Club read like a who's who of American business. The original roster included Richard Mellon (banking); Edward Dow and Irénée du Pont (chemicals); Bernard Kroger, Joseph Cudahy, and John Pillsbury (food retailing and processing); John Studebaker Jr. and Henry Ford (autos); John Wanamaker and C. S. Woolworth (retailing); Rodney Proctor (soap an toiletries); and many other. (Courtesy of Palm Beach Historical Society.)

Useppa Island, located in Pine Island Sound near Boca Grande on Florida's southwest coast, had a private nine-hole golf course built in 1916 by Barron Collier. The Useppa Golf Club House can be seen in the left background. (Courtesy of the Useppa Island Historical Society.)

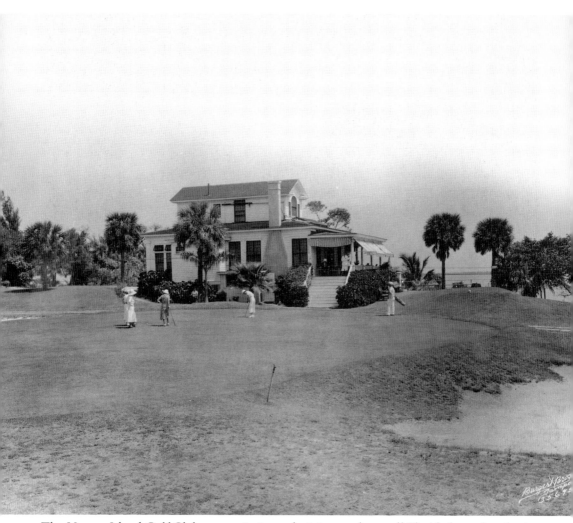

The Useppa Island Golf Club, secure in its exclusivity, used a small Florida bungalow for its clubhouse. Open only to the very wealthy and well connected in American society, members saw no need to advertise their club by building a larger clubhouse in the prevailing Mediterranean style of the 1920s. Four unidentified ladies, served by two caddies, practice their putting under the watchful eyes of men on the porch. (Courtesy of the Burgert Brothers Collection, Tampa-Hillsborough Public Library.)

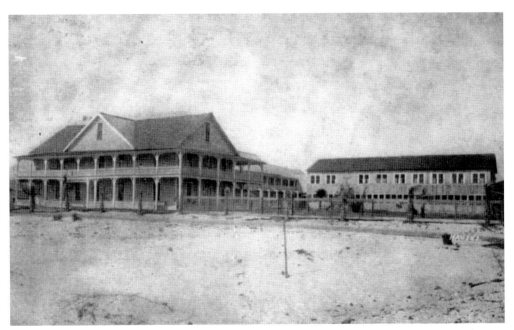

In addition to golf, the Ocean View Hotel on Jacksonville Beach offered visitors accommodations on the beach in a rambling wooden structure that captured the feel of a personal beach house. The Ocean View catered to middle-class Americans of the early 1900s, for whom organized vacations were relatively new things. (Courtesy of the Beaches Area Historical Society.)

The putting green of the second Fort Myers Country Club opened on December 29, 1917. This course was also designed by Donald J. Ross and was located on McGregor Boulevard. (Courtesy of the Fort Myers Historical Society.)

At the beginning of the 20th century, many Florida courses were little more than horse pastures like this one in Ocala. Many developers realized that these crude courses had little appeal and brought in renowned architects like Donald Ross and Seth Raynor to design and build new courses that challenged golfers at all skill levels. (Courtesy of the Moorhead Collection.)

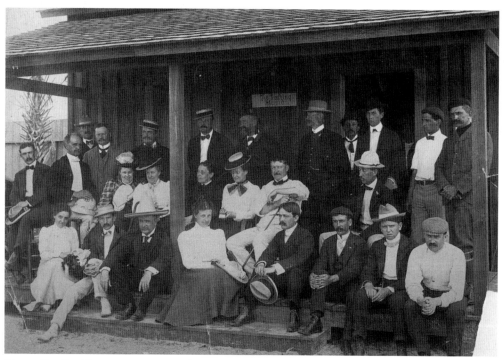

Henry Bradley Plant, wearing a sombrero, is surrounded by fellow golfers during a golf outing at the Tampa Bay Hotel. Notice the sign posted on the walls of the equipment shed that warns "No Loafing Allowed." (Courtesy of the Moorhead Collection.)

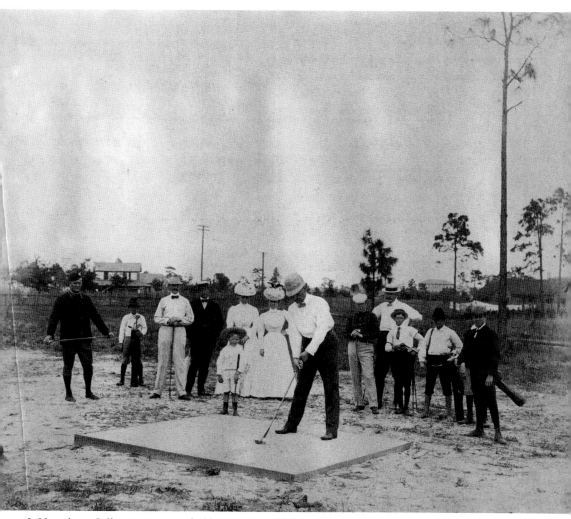

J. Hamilton Gillespie, surrounded by friends and other players, watches as a fellow golfer tees off on the second hole of the Gillespie nine-hole course in Sarasota in 1905. (Courtesy of the Moorhead Collection.)

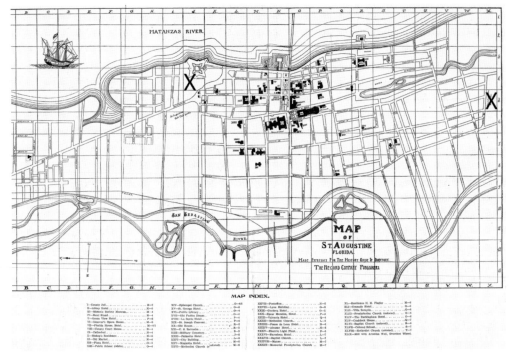

MAP INDEX.

This early map of St. Augustine shows the location of two golf courses in the early 1900s. Introduced by Henry Flagler for guests at his luxury hotels, golf has remained a major tourist attraction in the St. Augustine area. (Courtesy of the Florida Historical Society.)

Henry Plant's Belleview Hotel, built in the 1890s, was the largest wooden structure in the world when it was completed. The hotel, after going through several different ownership groups, is being completely restored and is open to the public. The adjacent Donald J. Ross course is no longer part of the hotel complex since being purchased by golfers who, according to local legend, were World War II veterans and refused to share it with the Japanese tourists who came to the hotel in droves when it was owned by a Nipponese company. (Courtesy of the Moorhead Collection.)

THE BEGINNING: 1886–1920

2

THE GOLF EXPLOSION

1920 – 1930

Although there was a decrease in the number of golfers in the Sunshine State during the turbulent years of World War I, Florida emerged from the conflict poised for a decade of unusual economic growth. Thousands of soldiers, sailors, and airmen who came to Florida for training were favorably impressed with the balmy climate and large areas open for development, and like their counterparts in World War II, many of these individuals were determined to return to the state and to bring their families.

Across the United States, significant social and economic changes reshaped the face of American society. The war brought about a major transfer of population from the rural areas of the nation to the larger towns and cities as machines, powered by internal combustion engines and initially introduced as weapons of war, were modified and adapted to farm use. The manpower requirements of animal-operated farms were significantly reduced, and the surplus farm labor became the workforces for the expanding factories in the cities. The lines between lower-class workers and the middle classes became blurred.

The introduction of the installment plan by Henry Ford and General Motors as a way to purchase automobiles fueled the demand for consumer goods, as "a dollar down and a dollar a week" became the American norm. Although initially introduced as a pre-payment scheme whereby consumers could make small payments to purchase cars and other items before actually receiving them, the installment plan idea was quickly revised to put the items in the hands of the purchaser before the full purchase price was paid. Debt, which had been viewed as an anathema by Americans prior to World War I, quickly became an acceptable part of the lives of most families.

For the American middle class, the installment plan allowed their full participation in all of the activities of the upper class, while the same program allowed lower classes to take on the appearance of the middle class. If automobiles and household items could be purchased with small monthly payments, why couldn't vacations, homes, and just about anything else?

The war was also responsible for infusing a sense of adventure into the American public. Although the frontiers of the nation had been finalized by 1900, there were large areas of unknown or sparsely settled territory that remained within the borders of the United States. Veterans, used to the adrenalin rushes of combat, were reluctant to return to their humdrum routines of the prewar years and sought new experiences. The sale of surplus military vehicles for low prices or the installment plan allowed them to purchase automobiles, which became the new Conestoga wagons as thousands of veterans with their families took to the roads and trails of America.

Florida was a favorite destination for these modern nomads, and they happily left the established routes along the coasts and made their way into the interior of the state to explore the savannas and prairies that had previously been the domain of isolated cowmen and their herds. Where no

roads existed, they blazed their own crude trails. They were dubbed "tin can tourists" by native Floridians, who complained because they carried virtually everything they needed for their expeditions. The widely parroted joke was that these tin canners arrived at the Florida state line with "ten dollars and an extra pair of underwear and when they left three months later, they had changed neither!" That was not exactly true. Natives quickly realized that these visitors were interested in seeing the unusual, and thousands of mom-and-pop businesses were created to sell supplies and provide exotic experiences.

While Florida's coasts had long been considered the domains of Henry Flagler, Henry Plant, and the upper classes, there were still large sections of the coastline that were unsettled, and the bright Florida sun belonged to nobody. Large areas of raw land in the interior, populated with countless small lakes and indolent rivers, offered less costly alternatives to the resorts of Plant and Flagler. With the right promotion and the right vision, new vacation destinations and housing developments—even entirely new towns—could be created on a scale that would overshadow the creations of these two men. These new visionaries' tasks were made easier by the millions of dollars that the Flagler and Plant companies had already spent marketing the Sunshine State as the leisure capital of the United States. As one wag said, "Europe may have the Riviera, but we have Florida. It's cheaper, has better beaches, a better climate than the Riviera and there's just so damned much of it!"

By 1919, hundreds of new towns were in the planning stages, and architects, engineers, and builders were waiting in the wings for the economic boom that was sure to come. While not every new development or town could count on having a beach or ocean view like Palm Beach or Ormond, they could count on Florida's perpetual sunshine. Developers quickly looked past the appeal of the sandy beaches and choose to market their new developments on local attractions and, most importantly, on the game of golf. Once again taking a page from the playbook of Flagler and Plant, these developers adopted the Mediterranean Revival style of architecture that dominated Palm Beach and Boca Raton. Miniature palaces and castles soon dominated the Florida landscape as lesser-known local architects sought to secure the same success as the designers of the much larger and more opulent homes on the East Coast.

By 1920, Florida land and Florida vacations were the hottest commodities American consumers wanted to buy. Trains brought investors south, and as they stopped in Jacksonville, the northernmost city in the state, they were boarded by hundreds of "binder boys" who carried suitcases full of deeds. So great was the demand for Florida land that these deeds were often bought and sold 10 or 20 times as the train made its way south to Miami. During this long 500-mile trip, great paper fortunes were made, as prices for land continued to rise with each transaction. Fueled by the small down payments required to bind the purchaser to the initial purchase, each transaction could be made with a minimum cash outlay and the remainder promised in installments. A bound property could be sold through the creation of another binder and a small down payment. Repeated numerous times and passing through a variety of different purchasers, the value of the land appeared to be increasing exorbitantly. What few investors seemed to care about was the massive amount of debt they accepted in order to be players in the game of real estate development. After all, these were the Roaring Twenties, and Florida real estate was what made them roar!

The massive debt that was ignored in the first half of the 1920s would eventually come back to haunt the buyers at the end of the decade. Paper fortunes disappeared overnight, visions of new towns and developments were left in tatters, and some individuals, overwhelmed by crushing debt, opted to take their own lives.

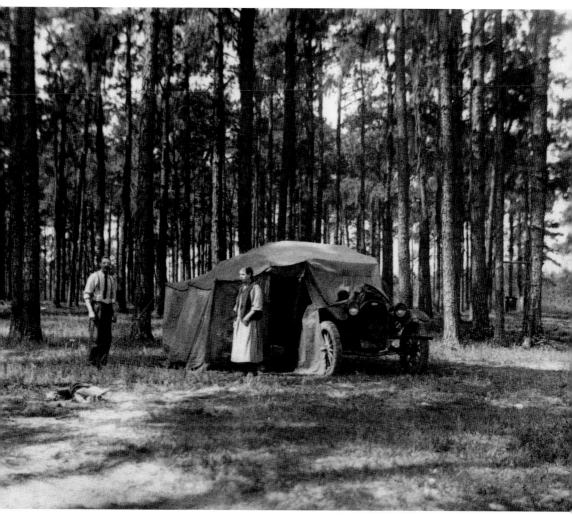

Florida's expansive interior plains and savannas were popularized by the tin can tourists who explored the natural wonders of the area. Loaded down with gasoline cans, tinned foodstuffs, and surplus army tents, they blazed new trails into previously unexplored regions. (Courtesy of the Florida Historical Society.)

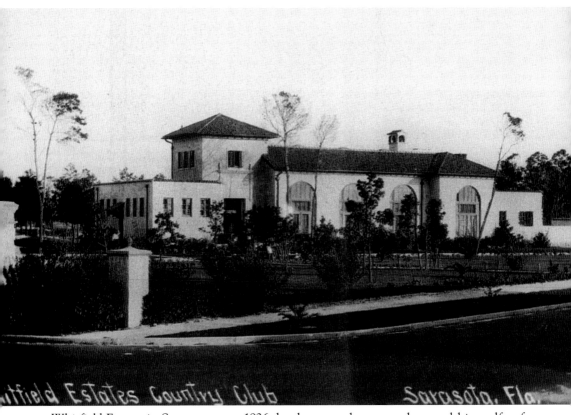

Whitfield Estates in Sarasota was a 1926 development that catered to wealthier golfers from the north. The clubhouse, shown here, has the distinction of being the oldest surviving clubhouse on Florida's west coast. Now known as the Sara Bay Club, the original Whitfield Estates property went through several identities as it changed hands over time. The original course was designed by Donald J. Ross and was the site of the first half of the 72-hole Match of the Century between professional "Sir" Walter Hagen and amateur Bobby Jones in 1926. (Courtesy of the Moorhead Collection.)

The Boca Grande Inn was a little-known golf resort on Florida's west coast that catered to the very rich from New York and New England. The inn featured a relaxed lifestyle and play on one of the best courses in the Sunshine State. Even today, the Boca Grande course is well maintained and is considered a "must play" for committed golfers. (Courtesy of the Boca Grande Historical Society.)

The Boca Grande Hotel provided visitors an opportunity to enjoy the calm waters of the Gulf of Mexico, tarpon fishing, and great golf. (Courtesy of the Boca Grande Historical Society.)

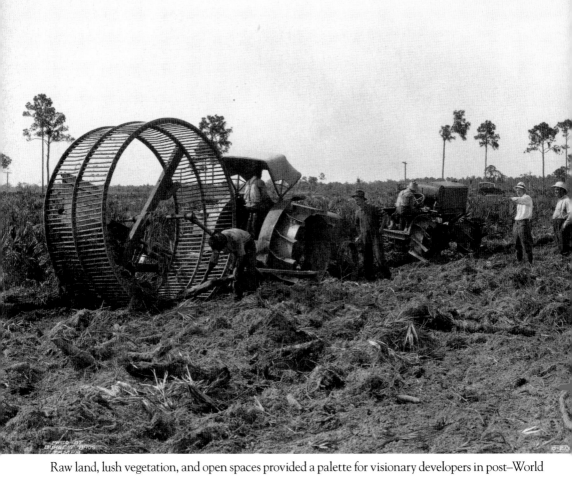

Raw land, lush vegetation, and open spaces provided a palette for visionary developers in post–World War I Florida. Few regions of the Sunshine State escaped the avaricious eyes of these opportunists. (Courtesy of the Florida Historical Society.)

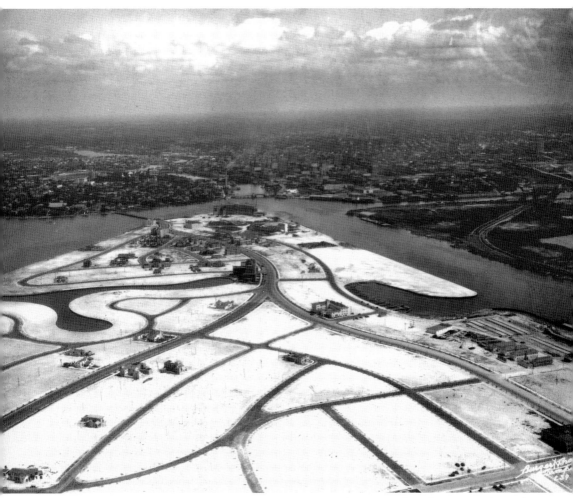

In established towns, developers created new subdivisions in the preferred Mediterranean Revival style that was so popular in the 1920s. Where no towns existed, they were created overnight as streets were carved out of the wilderness, homes were erected, and potential buyers were brought in to view and purchase a vacation home. Golf courses were the major attractions of the new developments. This photograph shows Davis Islands, a D. P. "Doc" Davis project, under construction in the early 1920s. (Courtesy of the Burgert Brothers Collection, Tampa-Hillsborough Public Library.)

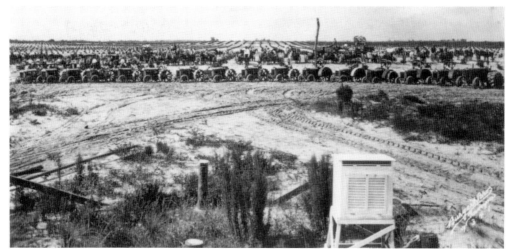

The demand for land was so great in the early 1920s that successful citrus farmers turned their groves into housing developments. Some promoters, like those behind the development of Temple Terrace and Howey-in-the-Hills, sold mini-groves along with homes to buyers. Most were assured that the income from the small groves would eventually pay the entire costs of their new homes. (Courtesy of the Burgert Brothers Collection, Tampa-Hillsborough County Public Library.)

The Everglades Golf Club House was a center for social activities in the 1920s. The Everglades Golf Course, designed by golden-era golf architect Seth Raynor, a protégé of early golf course architect C. B. Macdonald, was one of five courses advertised as open for play in the immediate Palm Beach area. (Courtesy of the Moorhead Collection.)

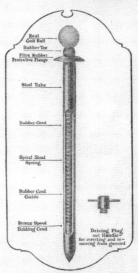

Very early in the 20th century, manufacturers realized that a sizeable market of golfers existed, and they advertised their wares to them. From the latest in golf fashions to aids for improving skills on the course, golfers could readily order just what they wanted. (Courtesy of the Moorhead Collection.)

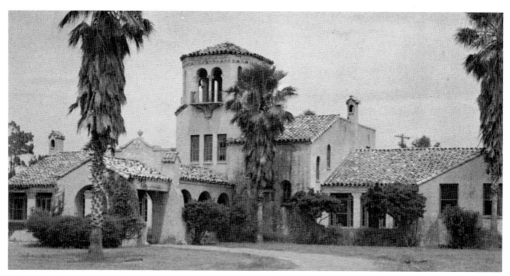

Jacksonville also offered residents and winter visitors a choice of five golf courses in the metropolitan area. Many, like the San Jose Golf Club seen here, featured elaborate clubhouses in the Mediterranean Revival style, which was the favored style of architecture during the Florida boom of the 1920s. (Courtesy of the Moorhead Collection.)

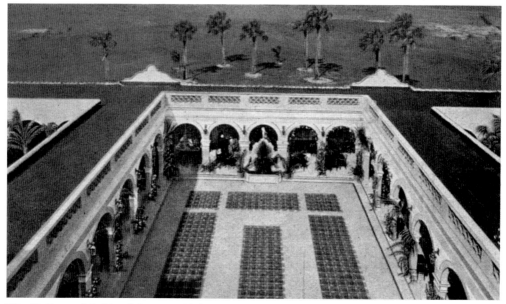

The Hollywood Golf and Country Club was typical of the many housing developments or planned communities built during the 1920s in Florida. Although clubs offered other amenities like swimming or tennis, golf was the principal attraction for many home buyers. There is nothing new under the sun, goes the old adage, and Florida developers are still using the lure of golf to attract buyers to the thousands of subdivisions that populate the landscape of the Sunshine State. The large open courtyard would be covered by a canvas roof during inclement weather. (Courtesy of the Moorhead Collection.)

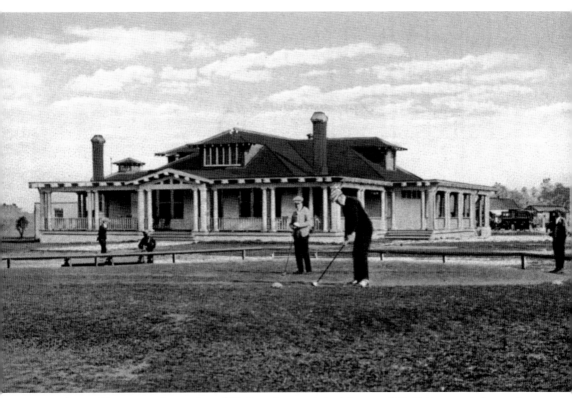

Legendary golf course architect Donald J. Ross designed the Municipal Golf Course on the north side of Jacksonville in 1922. The course was renamed Brentwood Golf Club in the 1940s and was integrated in the 1960s. (Courtesy of the Moorhead Collection.)

Pine Crest Country Club in Avon Park was frequented by rich Chicagoans in the 1920s. They came south in droves to escape the harsh northern winters. Once in residence in Avon Park, golfers were transported to the course at the popular Jacaranda Hotel by horse-drawn wagons. This course, maintained over the years, was recognized as one of the very best in the country after World War II. In 1959, NBC television selected it as the site of its very first televised golf tournament, the World Championship of Golf. Bob Crosby was the announcer. Don January and Gardner Dickinson were the featured players, although the eventual winner was Cary Middlecoff. (Courtesy of the Moorhead Collection.)

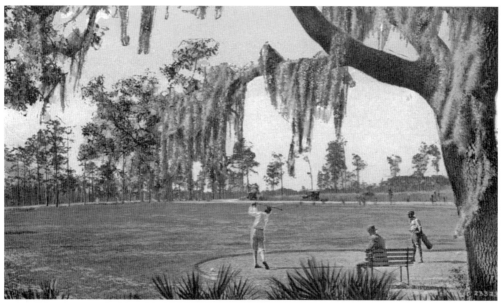

The Temple Terrace Golf Course, built amid flourishing orange groves near Tampa, sought to combine relaxation and profit for buyers of homesteads in the newly developed Temple Terrace community of the 1920s. Like most of its contemporary developments, the bust of 1926 and the Great Depression of the 1930s brought a halt to its growth. Homes built in Temple Terrace lacked a kitchen, since residents were expected to eat their meals at the clubhouse. (Courtesy of the Moorhead Collection.)

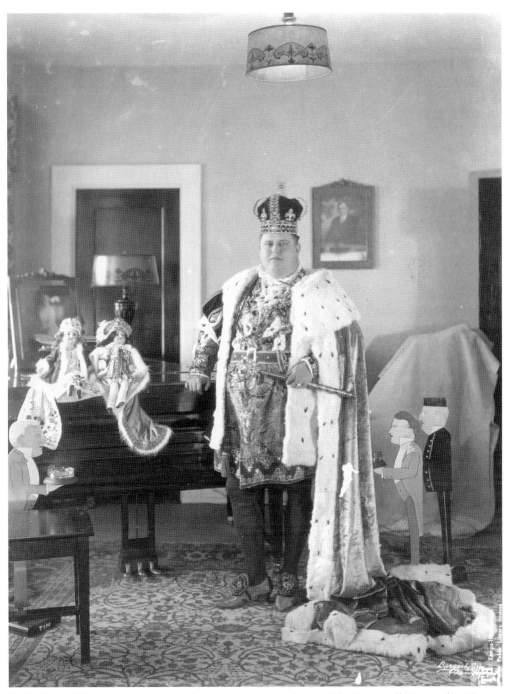

D. Collins Gillett is shown here in his costume as the king of the Gasparilla Festival in Tampa in 1923. Gillett was president of the citrus and land company behind the development of Temple Terrace. A fantastically wealthy developer in the early to mid-1920s, he fell victim to the Florida bust of 1926–1927 and died nearly penniless in the 1930s. (Courtesy of the Burgert Brothers Collection, Tampa-Hillsborough County Public Library.)

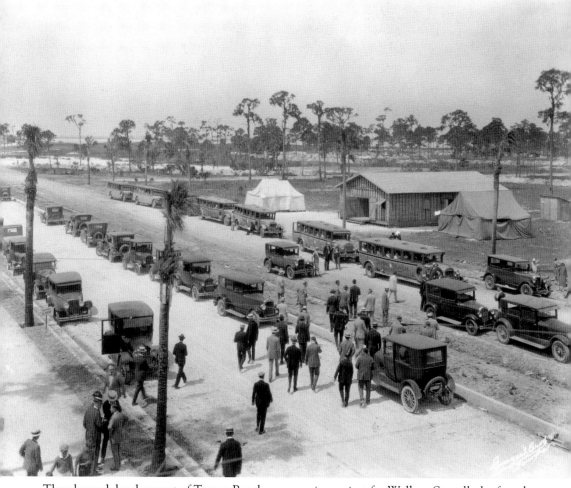

The planned development of Tampa Beach was a major project for Wallace Stovall, the founder of the Tampa *Tribune*, who sold his newspaper in 1925 to invest in real estate. By 1927, Tampa Beach became a casualty of the bust. Stovall, like many of his contemporaries, lost huge amounts of money on such developments. (Courtesy of the Burgert Brothers Collection, Tampa-Hillsborough County Public Library.)

Many Florida golf courses were built on large tracts of raw flat land with few distinctive features. The builders of the course at the Ocklawaha Hotel in Lake County attempted to relieve the unending monotony of the former orange grove where the course was built by engineering small earthen hazards for each hole. (Courtesy of the Moorhead Collection.)

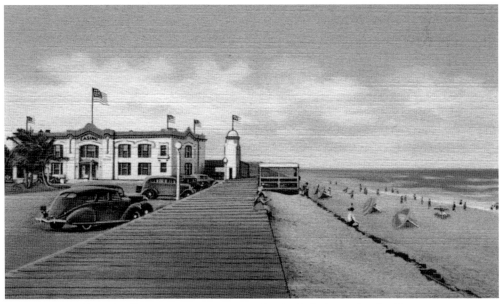

The casino and boardwalk were major attractions for the Indialantic-by-the-Sea community near Melbourne. A 4,800-yard, nine-hole golf course was attached to the hotel, just a short walk from the casino. (Courtesy of the Moorhead Collection.)

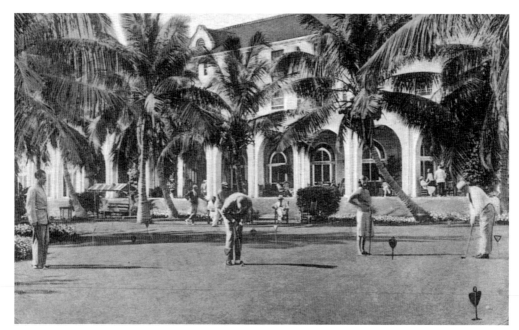

Golf courses were built throughout the Sunshine State in the first half of the 20th century, from Fernandina in the northernmost part of the state to Key West at the tip of the Florida Keys. Here golfers practice their putting in front of the Casa Marina clubhouse. (Courtesy of the Moorhead Collection.)

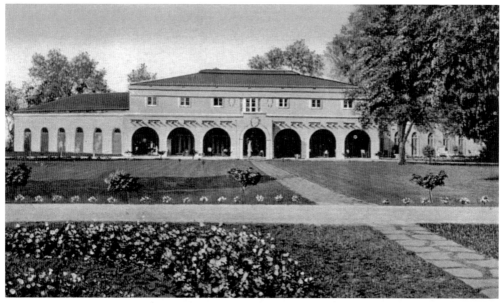

The Timuquana Golf Club putting green and clubhouse were built on the banks of the St. Johns River in the Ortega section of Jacksonville. An 18-hole Donald Ross–designed golf course was built across the street from the clubhouse and putting green. (Courtesy of the Moorhead Collection.)

THE GOLF EXPLOSION: 1920–1930

Donald Ross incorporated both natural and man-made hazards in his designs. The undulating green on the seventh hole of the Deland Country Club course is surrounded by "chocolate drops," which were the remains of materials cleared from the course during construction and integrated into the overall design. (Courtesy of the Moorhead Collection.)

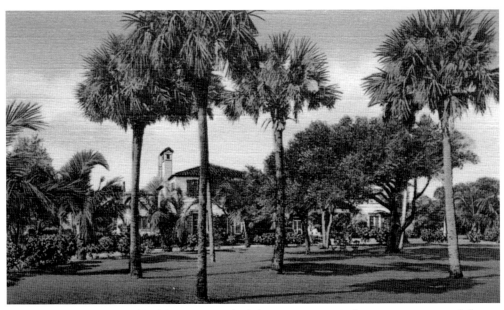

Vero Beach's Riomar Golf Club was typical of the many courses that were constructed during the 1920s. It remained as a nine-hole golf course until the 1960s. It is still Vero Beach's most prestigious venue for golf. (Courtesy of the Moorhead Collection.)

ALOMA LINKS

Hole	Yards	Bogy	Par	Handicap Stroke	Self	Partner	Opp.	Opp.
1	352	4	4	9	5	7		
2	288	4	4	12	4	9		
3	126	3	3	18	4	8		
4	357	4	4	8	6	10		
5	186	4	3	16	4	6		
6	263	4	4	15	4	6		
7	581	6	5	1	8	12		
8	276	4	4	13	4	5		
9	578	6	5	2	6	10		
Out	3007	39	36		45	74		

PLAYER_____

ATTESTED_____

DATE_____

This Card Measures Six In

These scorecards from the Aloma Links in Winter Park demonstrate the different skill levels of the golfers. One shot a 45 on the first nine holes, while the second golfer carded a 74. On the back nine holes, they did better. The first golfer finished with a score of 30 and his partner carded a 36. (Courtesy of the Moorhead Collection.)

Owing to the newness of the course, players are requested to use winter rules—improve your lie on fairways.

Hole	Yards	Bogy	Par	Handicap Stroke	Self	Partner	Opp.	Opp.	W L H
10	410	5	4	6	5	7			
11	315	4	4	11					
12	412	5	4	5					
13	393	5	4	7					
14	132	3	3	17	3	5			
15	496	5	5	3	3	6			
16	342	4	4	10	4	7			
17	265	4	4	14	4	5			
18	415	5	4	4	6	6			
In	3180	40	36		30	36			
Out	3007	39	36						
Total	6187	79	72						
HANDICAP									
NET SCORE									

when opened (Stymie Measure)

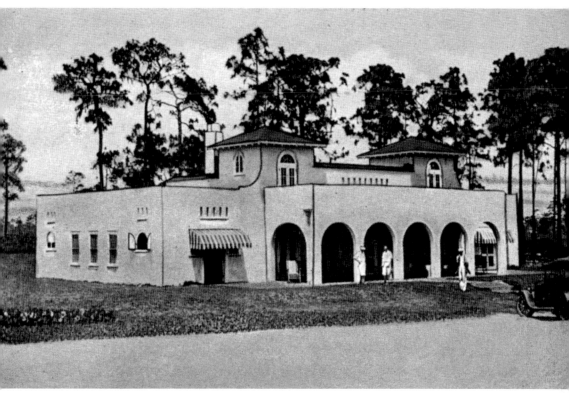

The old Clearwater Country Club, seen here around 1920, was built in the popular Mediterranean Revival style of the period. Golfers dressed for the occasion, and plus fours were the most popular style of attire. (Courtesy of the Moorhead Collection.)

Golfing was a year-round sport in the Sunshine State, as shown by golfers on one of the greens on the beautiful 18-hole Lake County Country Club in Eustis. (Courtesy of the Moorhead Collection.)

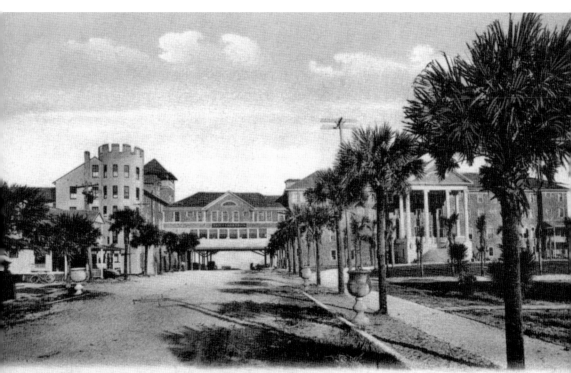

Clarendon Inn, Sea Breeze, Daytona, Fla.

blished in Germany for G. W. Morris, Portland, Maine.

The Clarendon Inn in Sea Breeze (Daytona Beach) was the primary lodging facility for golfers who enjoyed playing the five links-style golf courses in Volusia County—the Clarendon Golf Club (18 holes), the Daytona Golf and Country Club (18 holes), the Daytona Highlands Golf Club (nine holes), the Oseola-Gramatan Golf Club (nine holes), and the original 18-hole seaside layout at the Ormond Golf Links. (Courtesy of the Moorhead Collection.)

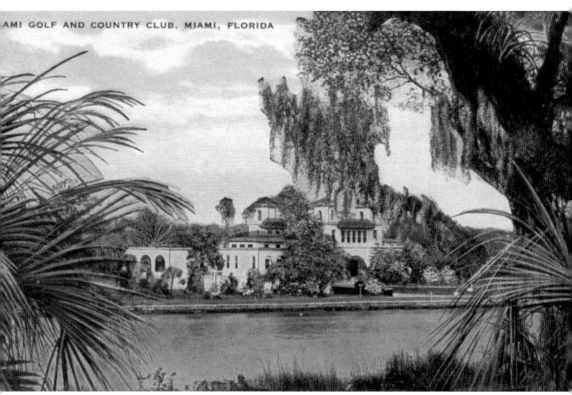

Golf was (and still is) a favorite form of recreation for winter visitors to Miami. Golf courses like the Miami Golf and Country Club furnished ample opportunities for the devotees of this popular pastime to enjoy the game all year-round. (Courtesy of the Moorhead Collection.)

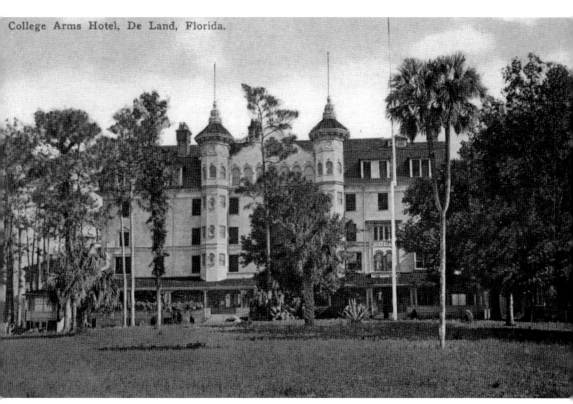

College Arms Hotel, De Land, Florida.

College students, parents, and tourists could enjoy a brisk round of golf at the College Arms Hotel in Deland. The 18-hole championship golf course was built across New York Avenue (State Road 44) just south of the hotel. (Courtesy of the Moorhead Collection.)

Dubsdread Golf Club was a Tom Bendelow–designed course built in 1924. Real estate developer and super salesman Carl Dann developed the course. It is located in the College Park section of Orlando, and each street is named for golf terms, such as Par Avenue, Niblick Drive, and Mashie Circle. (Courtesy of the Dubsdread Country Club.)

The Belleview Country Club featured a first rate club that was the product of several course architects, including the legendary Donald Ross. This 1931 view of the clubhouse reveals a muted Mediterranean influence that was shaped by the more modest architectural styles emerging in the Depression era. (Courtesy of the Moorhead Collection.)

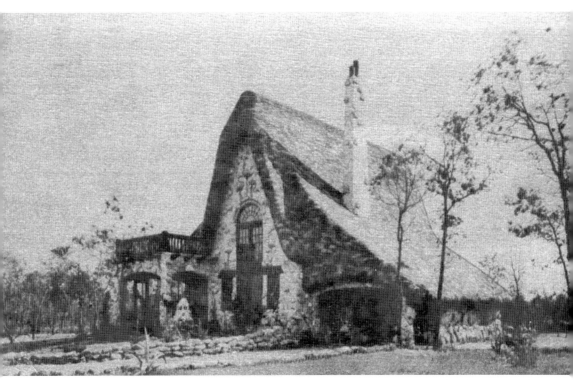

Pictured is one of the unique homes built at Mount Plymouth Golf Club, near Orlando in Central Florida. Architect Sam Stoltz, Chicago's artist builder, developed this very European look which attempted to blend nature and utility into a beautiful and functional home. Al Capone rented one of these houses on his frequent golfing vacations to Mount Plymouth. (Courtesy of the Moorhead Collection.)

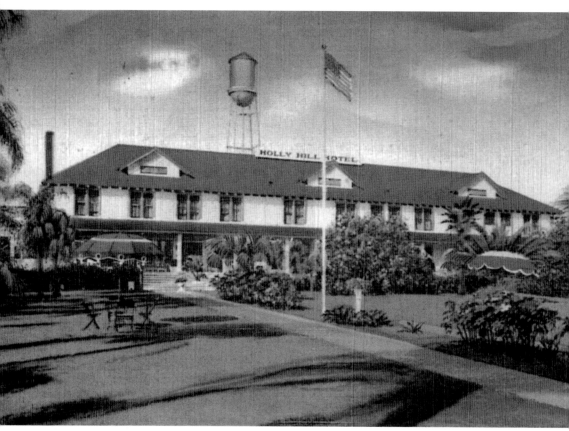

The Holly Hill Hotel in Davenport advertised its golf course as "Florida's Most Attractive." The long two-story hotel was surrounded by lush tropical and semitropical plants. The Holly Hill course was designed by Wayne Stiles and John Van Kleek and was considered to be of championship caliber, with one par-5 hole measuring over 600 yards in the 1920s. (Courtesy of the Moorhead Collection.)

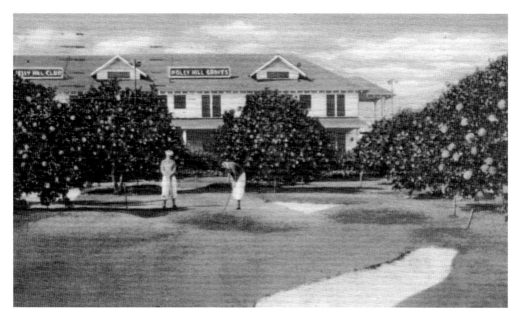

Among the chief attractions at the Holly Hill Golf Club Hotel is this sporty 18-hole miniature golf course known as "the Minny." The course was beautifully designed with grass tees, fairways, and miniature water holes right at the hotel steps. The course was lighted for evening play and was particularly enjoyed by lady golfers. Both the Minny and a full-size 18-hole golf course were designed by Wayne Stiles and John Van Kleek. (Courtesy of the Moorhead Collection.)

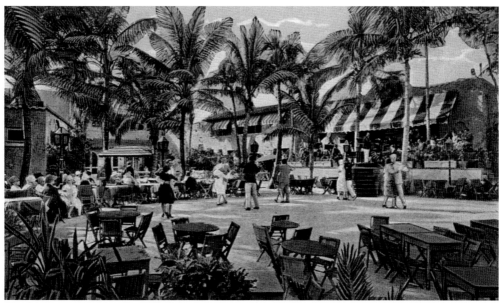

Coral Gables Golf and Country Club was the place to be in the Gables, where visitors enjoy the Spanish Dance Patio. This was the popular haunt of the pleasure-seekers in the Miami area. The patio was set in a cluster of coconut palms and landscaped in tropical plants and flowers. (Courtesy of Pictorial Centre, Miami.)

GOLF IN FLORIDA: 1886–1950

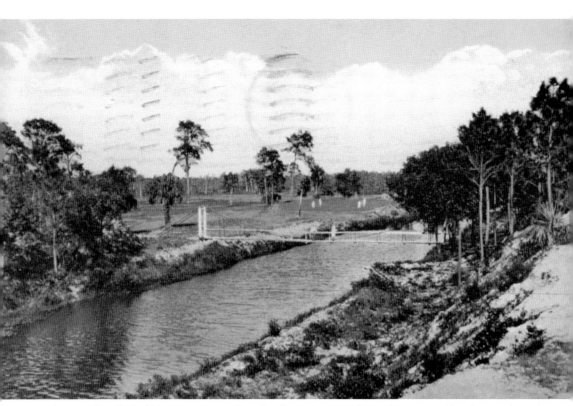

The Royal Park Golf Course in Vero Beach, shown here in the early 1930s, offered a number of holes with natural hazards. A large drainage canal split the course and could only be crossed via a narrow suspension bridge. (Courtesy of the Moorhead Collection.)

THE GOLF EXPLOSION: 1920–1930

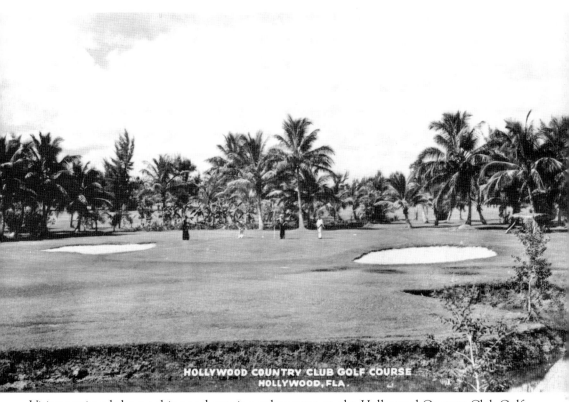

HOLLYWOOD COUNTRY CLUB GOLF COURSE
HOLLYWOOD, FLA.

Visitors enjoyed the sunshine and swaying palms trees on the Hollywood Country Club Golf Course. (Courtesy of the Moorhead Collection.)

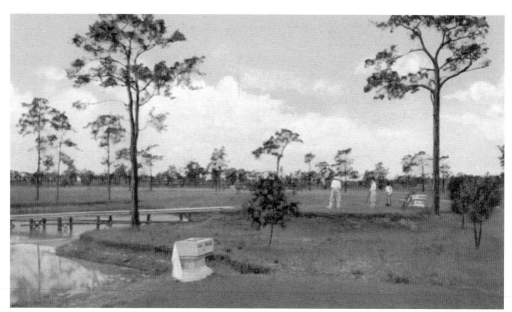

Everyday was golf day, as golfers came from all over Florida to play the Hotel Charlotte Harbor course in Punta Gorda. (Courtesy of the Moorhead Collection.)

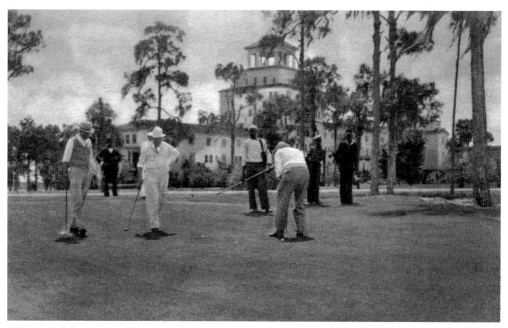

Harder Hall, located on the shores of Lake Jackson at Sebring, retains its elaborate Mediterranean-style clubhouse today. Notice the change of individual styles in the clothing of these golfers in the 1950s from that of the plus fours and neckties of golfers in the 1920s and 1930s. (Courtesy of the Moorhead Collection.)

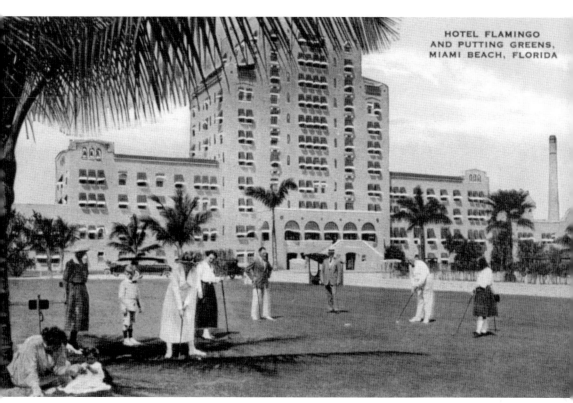

When wintry winds came to the north, many golfers made the trip to Miami Beach for the season and to play the coconut palm-laden fairways of the Flamingo Hotel and Golf Club. (Courtesy of the Moorhead Collection.)

The entrance to Avon Park's very exclusive and private Pine Crest Golf Club, also known as Pine Crest on Lotela, presented an imposing facade to the 3,170-yard, nine-hole golf course designed by Donald J. Ross. (Courtesy of the Moorhead Collection.)

The Seminole Hotel in Winter Park featured a different architectural style than many of its contemporary hotels. Modeled on an English country home, the ivy-covered hotel offered great lodgings, fine dining, and great golf. (Courtesy of the Moorhead Collection.)

The Pasadena Yacht and Golf Club course, built in 1923, features long straight fairways bordered by large water hazards. The course was designed by golden-era golf course architects Wayne Stiles and John Van Kleek in collaboration with golf professional Walter Hagen. This course was also the site of the second 36-hole Match of the Century won by "Sir" Walter 12-11 over Bobby Jones on Sunday, March 7, 1926. (Courtesy of Golf Shots Unlimited and the Moorhead Collection.)

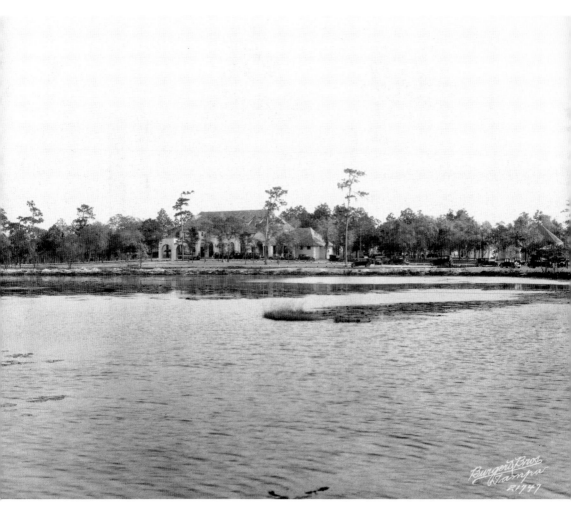

Like a large scar in the scrub oaks of rural Florida, the newly constructed Forest Hills Golf Club rose to dominate the low skyline of oaks and cypress trees. A tremendously popular club when it opened in the early 1920s, the course was located near Tampa. Later Babe Didrikson Zaharias made this her home course. (Courtesy of the Burgert Brothers Collection, Tampa-Hillsborough Public Library.)

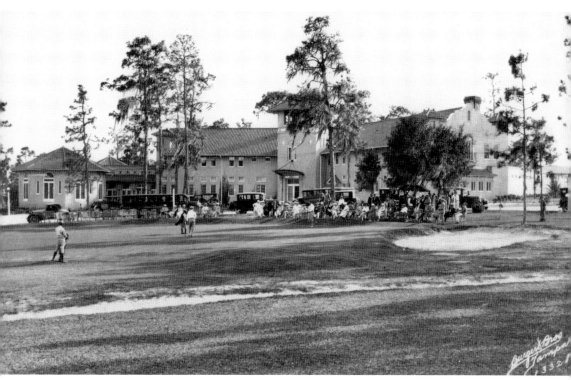

The Temple Terrace Country Club attracted wealthy members who welcomed the opportunity to play golf among the expanding orange groves. The many tournaments sponsored by the club attracted large galleries and prospective buyers. Notice on the left side of the photograph the large (and not air-conditioned) bus, which was used to transport prospective members on a tour of the development. (Courtesy of the Burgert Brothers Collection, Tampa-Hillsborough Public Library.)

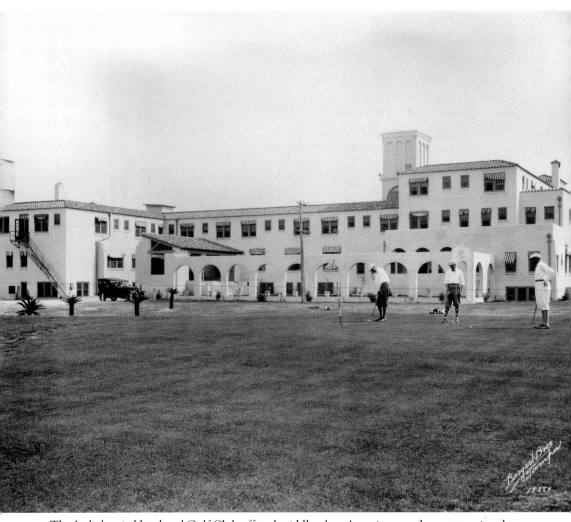

The Indialantic Hotel and Golf Club offered middle-class Americans a chance to enjoy the same recreational activities the wealthier upper class did at the more prestigious hotels operated by the Flagler business interests. A trio of golfers, clad in the latest styles of golfing attire, practice putting on the newly constructed course in 1923. The newly planted palm trees give mute evidence of the newness of this course. (Courtesy of the Burgert Brothers Collection, Tampa-Hillsborough Public Library.)

THE GOLF EXPLOSION: 1920–1930

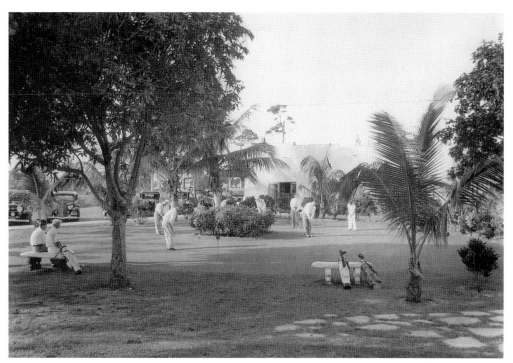

Men in dress shirts and neckties, the dress of the day for golf, practice putting on the green at the Miami Beach Country Club in 1920. Note the small bags and few clubs used in those days. (Courtesy of Historical Association of Southern Florida.)

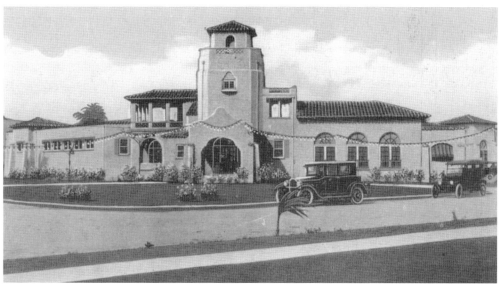

Vintage automobiles from the early 1920s are parked in front of the Hollywood Golf Club, which featured a Mediterranean Revival architectural style with multiple arches and a raised veranda. The club was leased by Chicago gangster Al Capone in 1929, and he operated it as a casino until 1931. (Courtesy of the Moorhead Collection.)

GOLF IN FLORIDA: 1886–1950

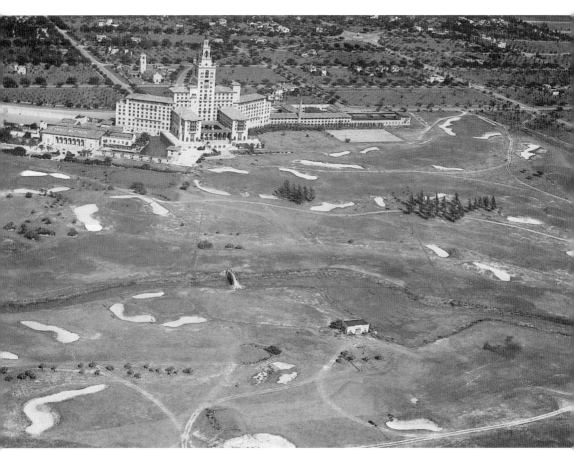

This aerial view of the Miami Biltmore Hotel and Golf Course was taken soon after the hotel opened in 1925. Donald J. Ross, the most prolific of golf architects in the 1920s, designed the two 36-hole courses at the Biltmore. In the 1940s, one of the courses was sold to a private group and became Riviera Golf and Country Club in Coral Gables. (Courtesy of the Historical Association of Southern Florida.)

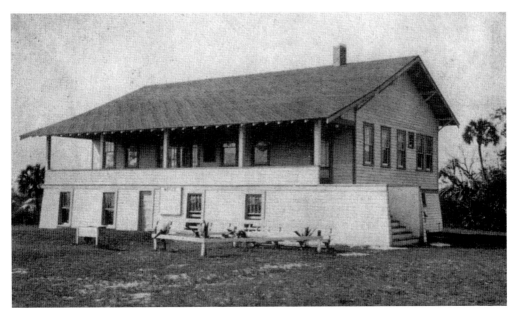

Somewhat plain, the original clubhouse of the *c.* 1923 Melbourne Golf and Country Club gave few hints about the magnificent Donald J. Ross course that stretched out before it. (Courtesy of the Moorhead Collection.)

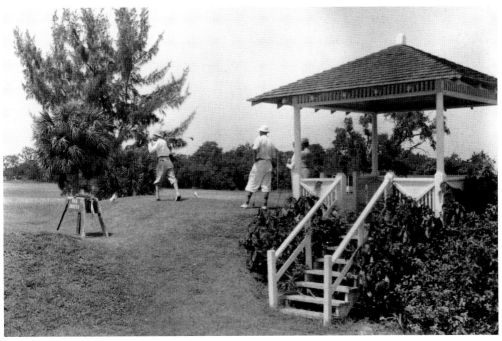

The Useppa Island Golf Club offered an insulated and exclusive retreat for America's wealthiest golfers. This foursome takes to the tee after a brief respite in the gazebo at the eighth hole. The Useppa course was very exclusive, open to members only. (Courtesy of the Burgert Brothers Collection, Tampa-Hillsborough Public Library.)

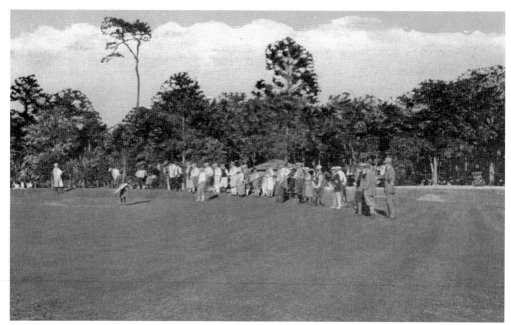

Golf courses in Florida always drew a large viewing gallery of fans and supporters of the new game imported from Scotland. (Courtesy of the Moorhead Collection.)

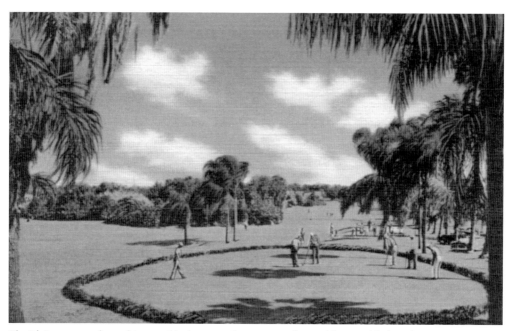

Florida's perpetual sunshine and balmy weather meant that golfers could play almost every single day of the year. Here golfers sharpen their skills on the practice putting green at the Clearwater Golf and Country Club. (Courtesy of the Moorhead Collection.)

THE GOLF EXPLOSION: 1920–1930

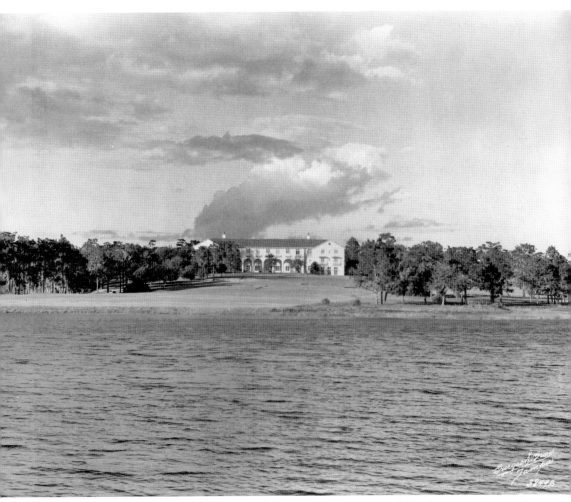

The clubhouse at Mountain Lake combined the continuous arches of Mediterranean Revival with the low profile of an English manor house. The Mountain Lake Golf Club, designed by C. B. Macdonald protégé Seth Raynor, marketed its bucolic and rustic setting as a pleasant change from the more urban courses in South Florida. (Courtesy of the Burgert Brothers Collection, Tampa-Hillsborough Public Library.)

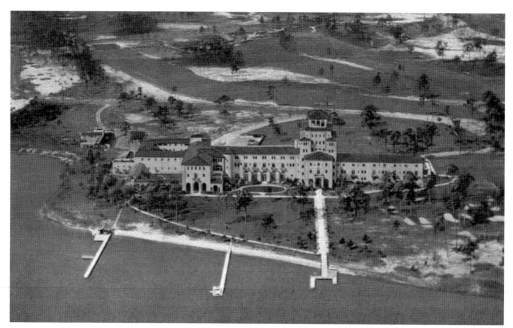

The imposing Harder Hall and the Lake Jackson Golf Links dominate the shoreline of Sebring. (Courtesy of the Moorhead Collection.)

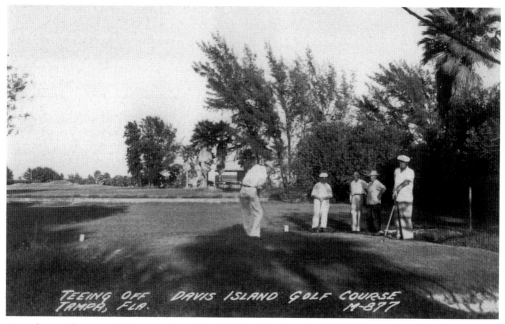

A rarely seen fivesome is shown teeing off on the No. 1 hole at the very private Davis Island Golf Course in Tampa. This nine-hole golf course was one of only three Florida courses designed by Philadelphia golf course architect Arthur W. Tillinghast. (Courtesy of the Moorhead Collection.)

THE GOLF EXPLOSION: 1920–1930

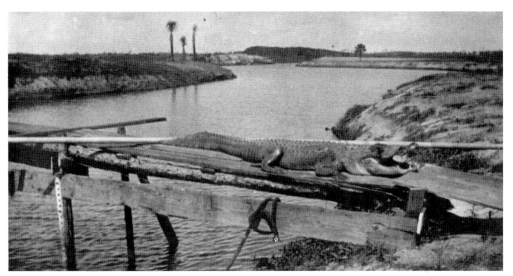

The first golf course at Mineral City (later Ponte Vedra) was constructed in 1928, just as the Florida boom was on its last legs. The alligator is supervising construction and getting a little sunshine. (Courtesy of the Beaches Area Historical Society.)

This is an aerial view of the Selva Marina Golf Club in Atlantic Beach. The Continental Hotel and, later, the Atlantic Beach Hotel sat on the land near the ocean's edge in the top right hand corner of the photograph. Some of the original holes of the Atlantic Beach Golf Club, designed by A. W. Tillinghast, are underneath some of the present-day holes at Selva Marina. These would be under the hole just below the circular road in the center of the photograph. (Courtesy of the Dave Hanson Collection.)

The original clubhouse for the Jacksonville Beach Club course, later the Ponte Vedra Inn and Golf Club, was built in 1928 and survived until 1999, when it was torn down and replaced with a parking garage. (Courtesy of the Beaches Area Historical Society.)

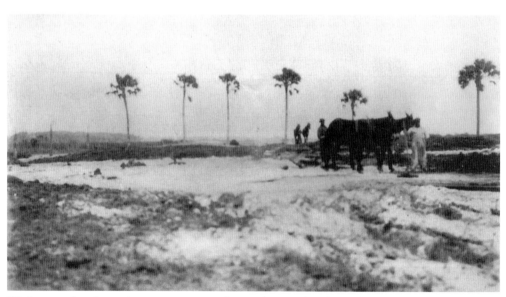

Workers used mules and scrapers to move the sand around to shape the fairways and tees for the Jacksonville Beach Club course in 1928. This was the name of the Ponte Vedra Inn and Club when it first opened. (Courtesy of the Beaches Area Historical Society.)

THE GOLF EXPLOSION: 1920–1930

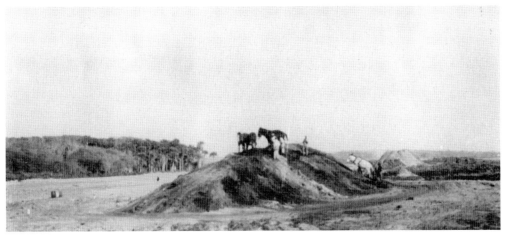

Men using mules and scraper pans hauled sand from the beach to form the hills and small elevations of the course at the Jacksonville Beach Club. Today's successor club, the Ponte Vedra Golf Club, still preserves remnants of the original course constructed in 1928 and 1929. These features were part of the original eighth fairway. (Courtesy of the Beaches Area Historical Society.)

A golfer waits his turn on the 18th fairway of the Mountain Lake course in the late 1930s. Caddies of the period were not overburdened, since most golfers had only four or five clubs in their bags. (Courtesy of the Burgert Brothers Collection, Tampa-Hillsborough Public Library.)

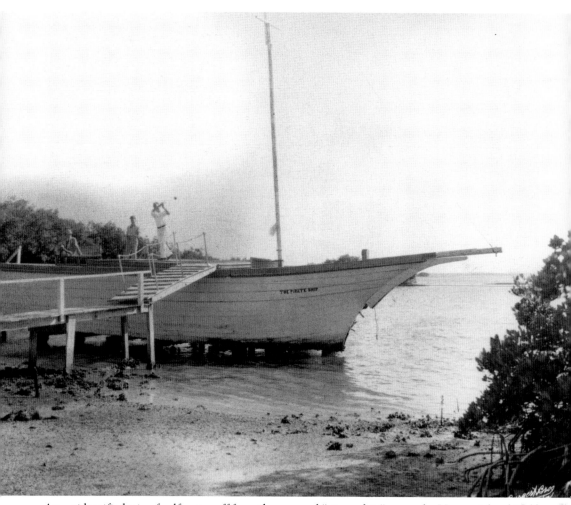

An unidentified trio of golfers tee off from the unusual "pirate ship" tee at the Useppa Island Golf Club. (Courtesy of the Burgert Brothers Collection, Tampa-Hillsborough Public Library.)

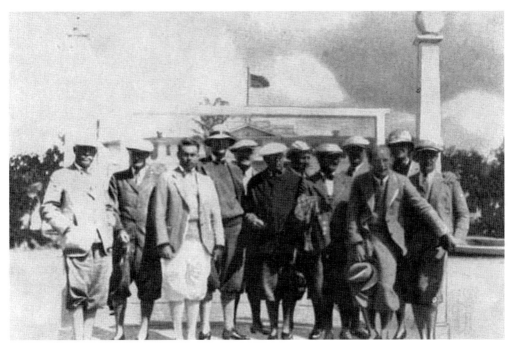

Although exclusively discriminatory when it came to accepting new members, the Useppa Island Golf Club fielded a skilled team of golfers who competed against other teams from around the Sunshine State. (Courtesy of the Useppa Museum.)

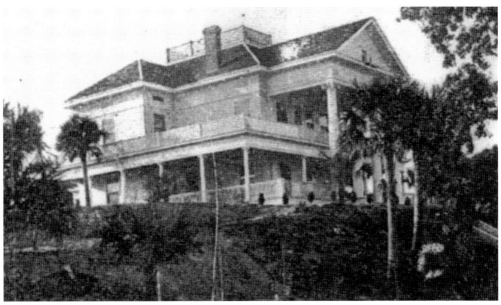

Although the Useppa Island Golf Club had a modest bungalow for a clubhouse, members were not bound by modesty when it came to building their own residences on the island. This Georgian-style mansion, complete with columns, verandas, and a widow's walk, was typical of the houses on the island. (Courtesy of the Useppa Museum.)

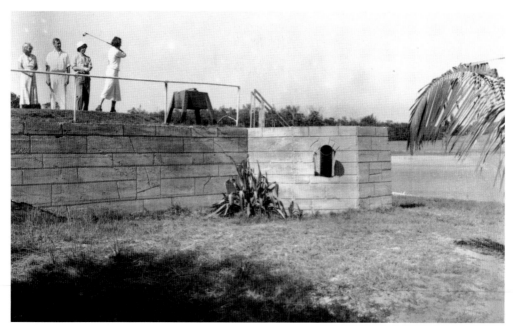

The "gun emplacement" tee offered golfers an elevated view of the otherwise flat Boca Grande Country Club course in the 1930s. (Courtesy of the Burgert Brothers Collection, Tampa-Hillsborough Public Library.)

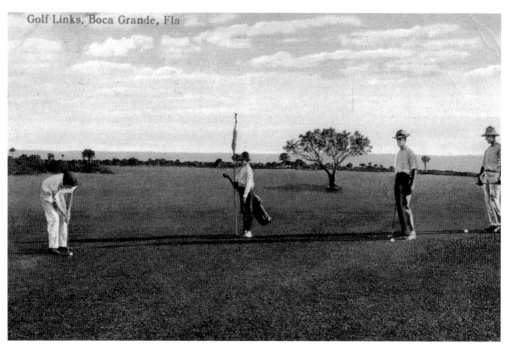

Golf Links, Boca Grande, Fla

The golf course at Boca Grande offered golfers a distracting view of the Gulf of Mexico. These golfers, however, seem more intent on putting the hole out than in gazing at the beautiful sunset behind them. (Courtesy of the Moorhead Collection.)

THE GOLF EXPLOSION: 1920–1930

3

THE BOOM AND THE BUST

1920 — 1940

For many Americans, the success of the Florida real estate boom seemed to have no end. Newspapers and magazines were full of advertisements that touted the success of new developments and focused on the recreational opportunities they offered. Most Americans received offers in the mail that explained how a small piece of this 20th-century Eden could be theirs for just a little money down and small monthly payments. Wealthier Americans were courted by full-color brochures that featured pictures or drawings of homes for the well-to-do or scenes that assured them that golf and other recreational activities could be enjoyed throughout the year. Postcards that depicted luxurious country club houses complete with retractable roofs and lighted dance floors, pools and restaurants, were favored ways to recruit potential buyers. Promoters also employed hundreds of professional athletes, second-tier politicians and actors, and creative events to convey the "fun, fun, fun" image of Florida. William Jennings Bryan, a three-time presidential candidate, became a celebrity salesman for George Merrick's Coral Gables, while baseball icon Babe Ruth and champion boxer Jack Dempsey lent their support to other developers through personal appearances and written endorsements. Bobby Jones, the gifted amateur golfer, made frequent appearances in tournaments, often in match play against professionals like "Sir" Walter Hagen. "Clock golf" and "archery golf" were introduced to the golfing public, while the use of elephant caddies added a touch of the bizarre. Unusual promotions like these generated a lot of interest, but at the same time, they masked a growing sense of urgency on the part of developers to attract more buyers from a diminishing pool of potential customers.

Developers like Carl Fisher, D. P. "Doc" Davis, George Merrick, and numerous smaller ones had invested millions of dollars in creating their dream communities. Most of the construction costs were financed through loans secured from banks or by the personal fortunes of individuals. Whether the money came from banks or individuals, the reality was that its availability was based on the performance of the stock market. Like the Florida real estate market, the stock market was overheated during the 1920s, and stocks were bought and sold by the millions—often without regard for their actual values. The installment plan, which had fueled the consumer market, was mirrored by margin buying, a technique used to acquire stocks by paying a small percentage of the selling price. Whatever debt was left was assumed by the next buyer. Great paper fortunes were made overnight as stocks—often the only assets of the companies they were issued by—changed hands. Individuals who were lucky enough to sell their stock holdings realized tremendous profits, while those who bought hoped that they too would be able to sell them. As long as the market continued to attract buyers, the system worked. By late 1928 and early 1929, there were indications

that the upper limits of stock sales had been reached and only the superhuman efforts of brokers and major investors averted a market crash. Many of the stocks in the market were geared to real estate developments in Florida, and when that market faltered, the ripple effect impacted the stock market as a whole.

In October 1929, the house of cards that was the market collapsed, and when it did, it brought about the ruin of individuals and companies that had issued speculative stocks, banks that had made loans for real estate developments and stock purchases, and home owners who had borrowed to buy homes and consumer goods, and led to a general collapse of the American economy.

By late 1925 and early 1926, the first cracks in the Florida real estate bubble appeared, as land prices rose steadily upward to unheard-of heights. The devastating category-four hurricane that leveled much of Miami in September that year caused many new residents and visitors to reconsider their perception of Florida as the ideal vacation and retirement venue. Even 1927's hurricane-free season did little to restore confidence that 1926 had been an aberration. When a category-five storm struck in September 1928, their worst fears were confirmed. Coming ashore at Palm Beach, the storm struck across South Florida, leaving almost 5,000 persons dead and inflicting an estimated $156 billion in 2005 dollars in damages to real property. Although most of the dead were migrant farm workers who lived under the dikes of Lake Okeechobee, the major monetary damages were suffered by the housing developments, new towns, and resorts that made up the base of the boom. Two major hurricanes, separated by a single year, delivered a coup de grace to real estate development in the Sunshine State. Two years ahead of the rest of the nation, Florida experienced the economic depths of the Depression.

The storms, however, were only the final blows that killed the boom. The Florida real estate market, even during its heyday, had always been an iffy proposition. As new developments proliferated, less and less desirable acreage was subdivided into communities; streets were graded; curbing was installed and houses built. Golf courses, considered the ultimate attraction for buyers, were rushed to completion—often before the first houses were built or the first family moved in. By 1925, fewer and fewer buyers could be found for these developers. By the middle of the decade, some of the less desirable developments were closed, forced into bankruptcy as their owners exhausted their personal fortunes or failed to find new financing to complete their projects.

As more and more of the Florida golf communities began to fail, they left behind a commitment to the game that extended to the general public. When development corporations could no longer afford to maintain the courses they had built, some of these were given or sold to municipal authorities. While some of these courses were eventually sold back to private interests, some are still owned and operated by cities.

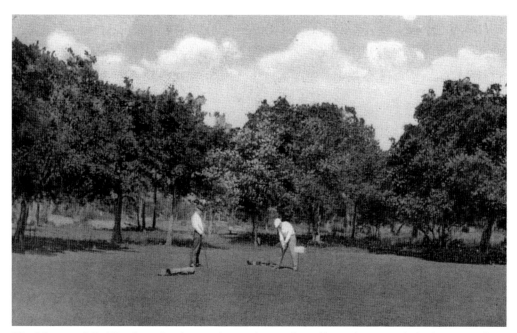

The Municipal Golf Links in Bradenton featured a number of hazards, particularly the native flora, which was incorporated into the overall design of the course. The course proved very popular with the thousands of "trailer tourists" who camped in the large Bradenton Municipal Trailer Park each winter. Here a twosome plays a round in 1929. (Courtesy of the Moorhead Collection.)

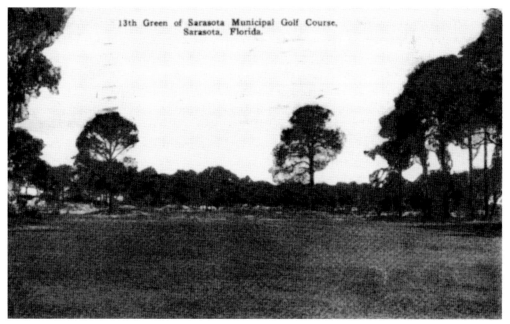

The municipal course in Sarasota featured a number of engineered hazards and obstacles to overcome the flat-as-a-pancake topography of the Sarasota Bay area. (Courtesy of the Moorhead Collection.)

Orange Brook Golf Club, Hollywood, is a municipal 18-hole golf course built during the 1930s in Florida. Many of the golf greats have played it and acclaimed it one of the South's finest. (Courtesy of the Moorhead Collection.)

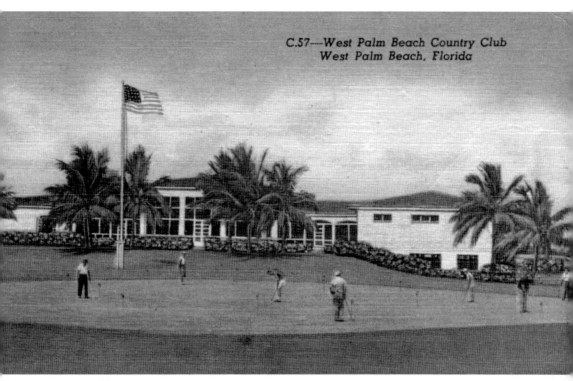

C.57—West Palm Beach Country Club
West Palm Beach, Florida

West Palm Beach Country Club, owned by the City of West Palm Beach, featured this practice putting green with a clubhouse, in background. One of the best designed and maintained golf courses in the United States and open to the public, this was one of the 40 golf courses in the Sunshine State designed by Donald J. Ross, the dean of golden-era golf course architects. (Courtesy of the Moorhead Collection.)

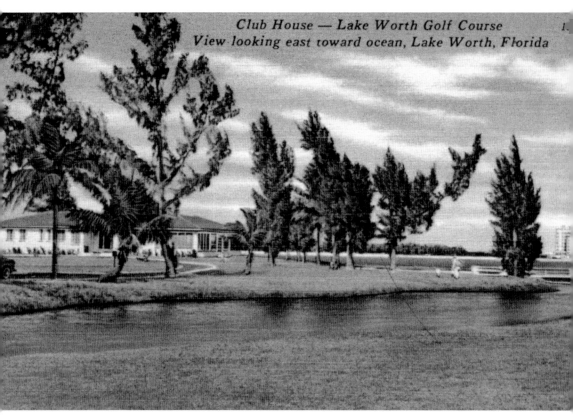

The Lake Worth Municipal Golf Course's 18th green was located on a point looking out over the beautiful and placid Lake Worth toward the ocean. Note the Australian pines brought in during the 1920s to prevent wind erosion. (Courtesy of the Moorhead Collection.)

Almost in the geographical center of the state, Orlando is a major resort and distribution hub for Florida. Millions of tourists visit the city annually to tour the numerous theme parks in the area. In addition, Orlando, known as the "City Beautiful," has become a major center for amateur and professional sports. Dubsdread Country Club is the only municipal golf course in the city. (Courtesy of the Moorhead Collection.)

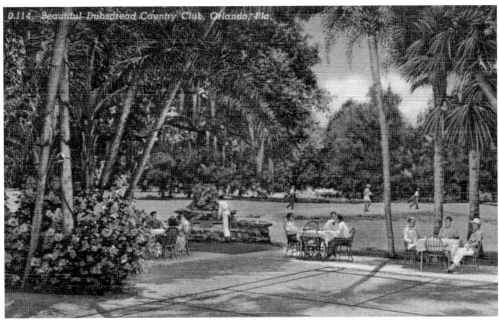

The Dubsdread Country Club patio and barbecue pit is located amid the tropical beauty of the 18-hole golf course. Many famous professional golfers, such as Sam Snead, Ben Hogan, Walter Hagen, and Ky Laffoon, made this course famous during the first half of the 20th century, while many of today's professionals consider it a course worthy of playing. (Courtesy of the Moorhead Collection.)

The clubhouse at the Dubsdread Golf Club in Orlando was the place to see and be seen in Orlando during the Roaring Twenties. The golf course was recently redesigned by Orlando golf course architect Mike Dasher. (Courtesy of Dubsdread Golf Club.)

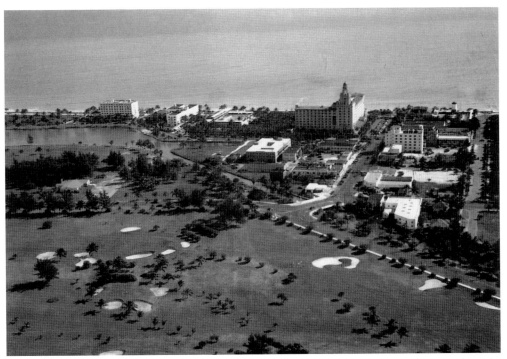

One can almost feel the ocean breeze through the palm trees in this 1928 aerial photograph of the Miami Beach Municipal Golf Club. (Courtesy of Historical Association of Southern Florida.)

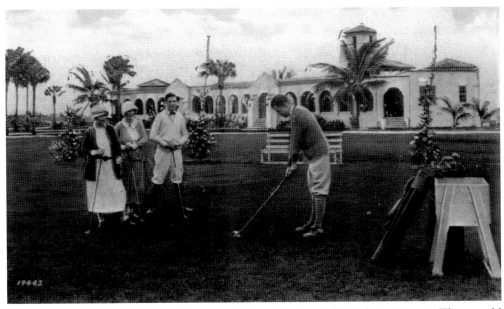

A mixed foursome tees off at the second Royal Palm Golf Club in Miami. This would later be known as the Miami Country Club before becoming a victim of increasing real estate values in the 1930s. Jackson Memorial Hospital occupies this site today. (Courtesy of Historical Association of Southern Florida.)

A gallery of fans follows the progress of their favorites in a Holly Hill tournament in the 1920s. The newly constructed course had a dearth of fully matured trees and plants. Today these young trees have matured to provide potentially disastrous hazards for errant golfers. (Courtesy of the Moorhead Collection.)

Two golfers take a break while playing the Hickory Hills course near Brooksville. In keeping with its rural surroundings, the Hickory Hills clubhouse was constructed in the rambling Cracker style of architecture, which featured high ceilings, a low profile, and screened porches. Mosquitoes, which were not effectively controlled in Florida until the 1940s, plagued golfers as they played the course carved into the rural landscape. (Courtesy of the Burgert Brothers Collection, Tampa-Hillsborough Public Library.)

THE BOOM AND THE BUST: 1920–1940

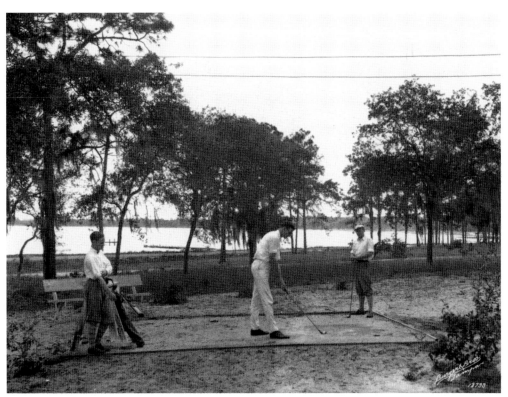

A trio of golfers, including a rare left-handed golfer, tees off for the first hole on the Silver Lake Golf Course near Leesburg. Unlike his fashion-plate companions with their knickers and golf shoes, this player maintains his unique method of play in his dress as well. (Courtesy of the Burgert Brothers Collection, Tampa-Hillsborough Public Library.)

Evoking the Cracker style of architecture indigenous to the Sunshine State, the Silver Lakes clubhouse provided a large screened porch where golfers could relax and avoid the hordes of mosquitoes that the nearby lakes supplied in abundance. (Courtesy of the Burgert Brothers Collection, Tampa-Hillsborough Public Library.)

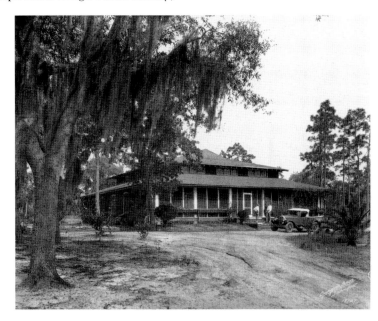

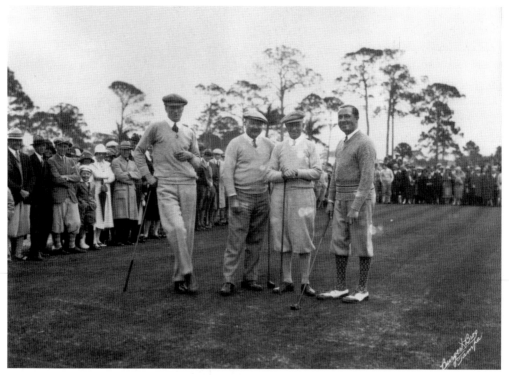

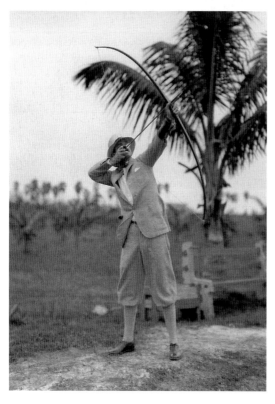

"Long" Jim Barnes, the golf professional at the Temple Terrace Country Club (left), and golf legend Walter Hagen (far right) participate in a demonstration at the Pasadena Golf Club in St. Petersburg around 1925. Hagen was the premier golfer of the period and occasionally designed courses. (Courtesy of the Burgert Brothers Collection, Tampa-Hillsborough Public Library.)

Archery golf was played at the Miami Beach Country Club a few times a year on special occasions. Archery golf uses a bow and arrow in lieu of golf clubs. The game is played on a regulation-sized golf course with the "holes" being a tin can with a tennis ball on top. The player who knocks the tennis ball from the can in the fewest number of shots is the winner. (Courtesy of Historical Association of Southern Florida.)

New York Yankee baseball great
Babe Ruth and Gov. Al Smith
pose for a photograph at the
Miami Biltmore during a pro-
am event preceding the 1931
Miami Four-Ball Tournament.
(Courtesy of the Historical
Association of Southern Florida.)

From left to right, Johnny Farrell,
Gene Sarazen, Leo Diegel, an
unidentified golfer, and Walter
Hagen pose for a photograph
prior to the Miami Open in
1930 at the Miami Country
Club. (Courtesy of Historical
Association of Southern Florida.)

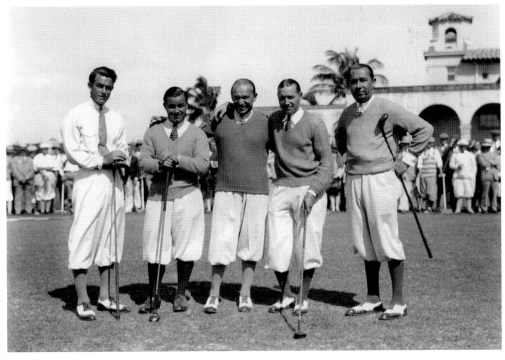

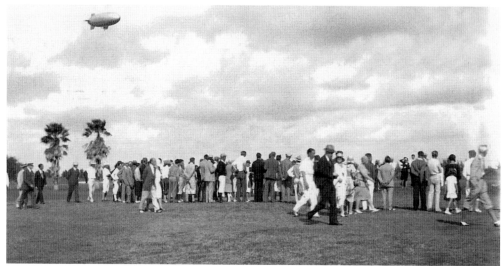

A blimp provides a good viewing opportunity for radio commentators during the Miami Open at the Miami Country Club in 1932. Today's tournaments frequently offer television viewers bird's-eye views from corporate-sponsored blimps. (Courtesy of the Historical Association of Southern Florida.)

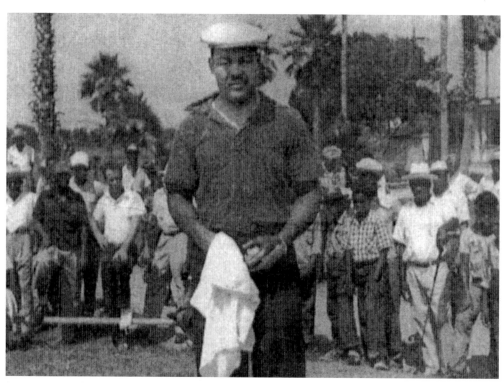

Boxing legend Joe Louis played at the Lincoln Golf and Country Club in the 1930s. The Lincoln club was founded by African American insurance magnate A. E. Lewis in Jacksonville in 1929. This was one of the few all–African American golf courses in Florida. (Courtesy of the Moorhead Collection.)

Many sports figures liked to wager on how well they could play against skilled golfers. This photograph at the Miami Beach Golf Club shows a jai alai player putting with his cesta. The tennis player, baseball player, and golfer are looking on. This match was won by the golfer. (Courtesy of the Historical Association of Southern Florida.)

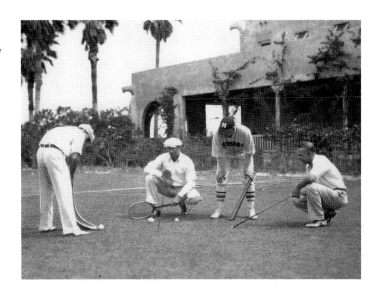

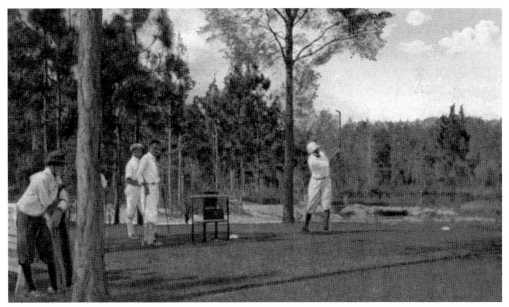

Hugh R. Loudon, a well-known amateur golfer of Florida, plays a perfect iron shot to the third green at Holly Hill Country Club during a match with Orville W. Chapin, a professional from Minneapolis; Tom C. Dobson, the Holly Hill Country Club professional; and Jim Powers, the assistant pro at Holly Hill. Loudon, paired with Dobson, won the match. The photograph shows Loudon, with his iron suspended in mid-air, immediately after the ball left the tee. (Courtesy of the Moorhead Collection.)

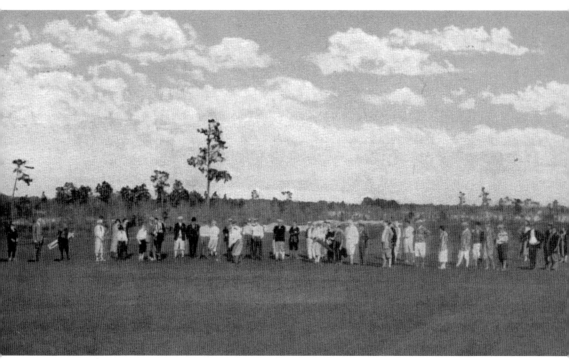

A gallery watches golfers playing the course during the inaugural match at the opening of the Holly Hill Country Club in Davenport. Tournaments proved to be popular entertainments (and successful sales tools) to bring potential customers to golf courses in the 1920s. (Courtesy of the Moorhead Collection.)

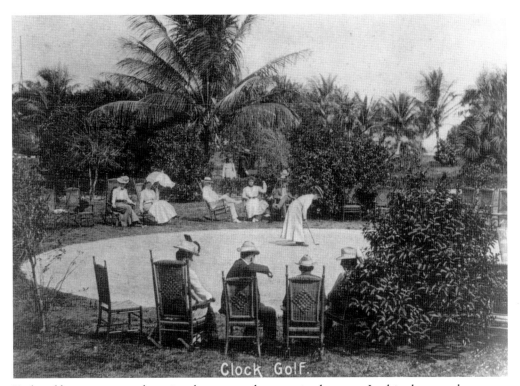

Early golf promoters sought to involve men and women in the sport. In this photograph, a group of female golfers enjoy a game of clock golf, which involved putting from specific points on the green that duplicated the face of a clock. This game was played at the Royal Palm Golf Club in 1915. (Courtesy of the Historical Association of Southern Florida.)

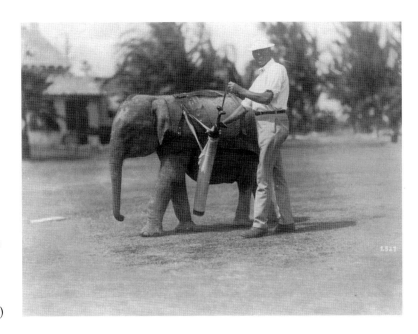

Rosie the elephant works as a caddy in this publicity shot in Miami during the 1920s. (Courtesy of the Historical Association of Southern Florida.)

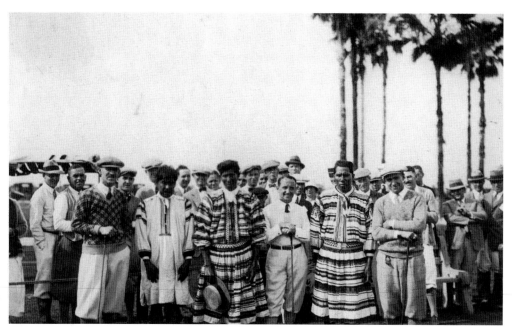

Abe Mitchell (left), Bobby Cruickshank (center), and "Wild Bill" Mehlhorn (right) pose with Miccosukee Indians at the Hialeah Golf Links in Miami in 1928. (Courtesy of the Historical Association of Southern Florida.)

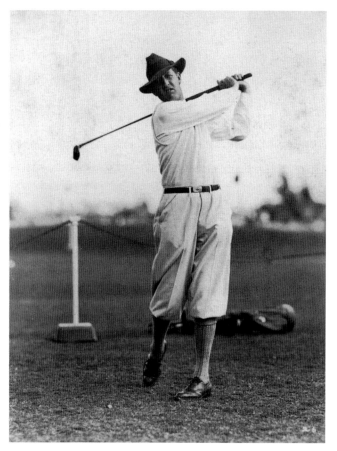

MacDonald Smith, a well-known golfer in the 1920s, is seen playing the La Gorce Country Club course in Miami Beach in 1928. (Courtesy of the Historical Association of Southern Florida.)

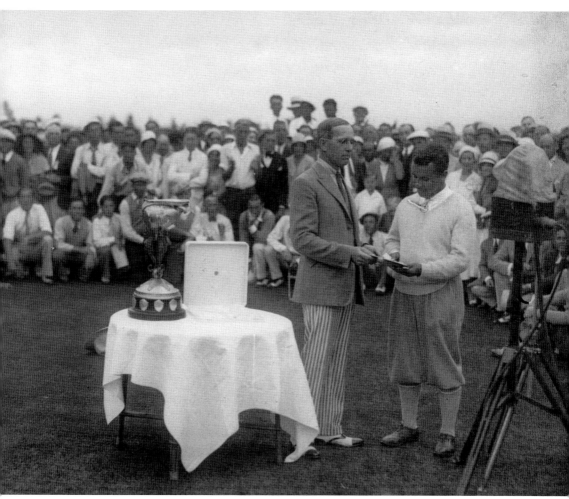

Gene Sarazen, who always had a large gallery when he played in a tournament, was the winner of the 1931 Miami Open. (Courtesy of the Historical Association of Southern Florida.)

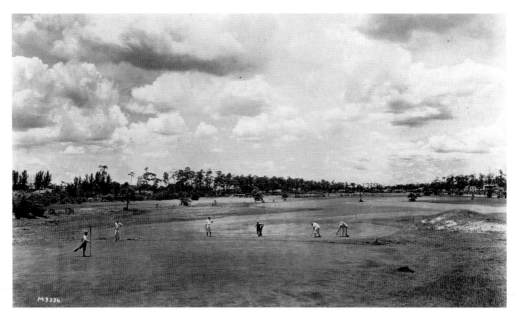

A foursome with their caddies enjoys a nice round of golf on a balmy day at the Coral Gables Country Club around 1927. (Courtesy of the Historical Association of Southern Florida.)

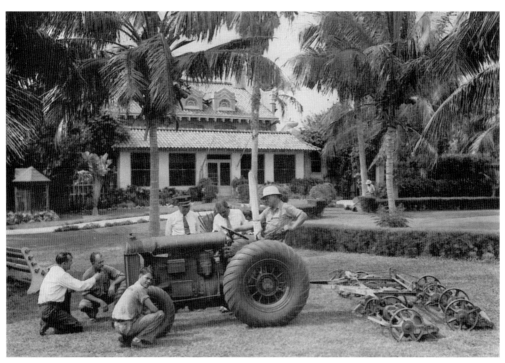

The credit for keeping any golf course in immaculate playing condition has to go to the maintenance crews and groundskeepers. Here they are shown making some adjustments to a new tractor and lawn mower at the Miami Beach Country Club around 1931. (Courtesy of Historical Association of Southern Florida.)

THE BOOM AND THE BUST: 1920–1940

This anonymous Florida golf course, like most of its contemporaries built in the 1920s, featured a Mediterranean Revival style of architecture. The bank of lights, framed by two tall palm trees in the center of the picture, illuminated tennis courts for nighttime playing. (Courtesy of Historical Association of Southern Florida.)

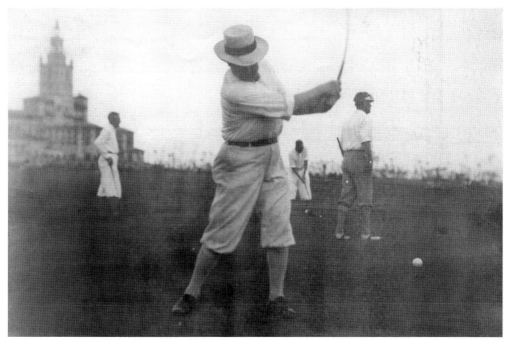

Gov. James Cox of Ohio was an avid golfer. In this photograph, he is teeing off at the Miami Biltmore course, probably in 1925. (Courtesy of Historical Association of Southern Florida.)

Leo Diegel and Johnny Farrell were two of the most popular professional golfers to play at the Hialeah Municipal Course. The winner of more than 30 tournaments, Diegel was the golfer credited with ending the career of "Sir" Walter Hagen when he beat him in 1928 and 1929. Farrell won eight consecutive tournaments in 1927. This photograph is probably from 1930. (Courtesy of Historical Association of Southern Florida.)

This is the original William Flynn layout for the Indian Creek Golf Club course in Miami–Dade County. Flynn was one of the golden-era golf architects of the first rank. Indian Creek is known as America's most exclusive town. In 2004, the U.S. Census Bureau recorded a population of only 38. A police force of 14 sworn officers makes Indian Creek the most protected town in America. (Courtesy of Historical Association of Southern Florida.)

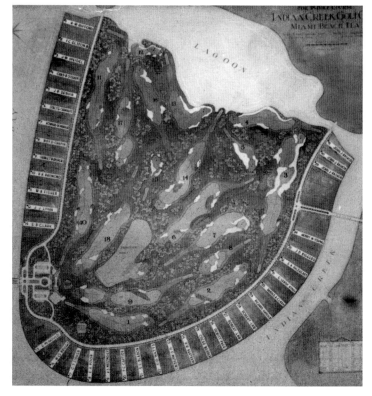

THE BOOM AND THE BUST: 1920–1940

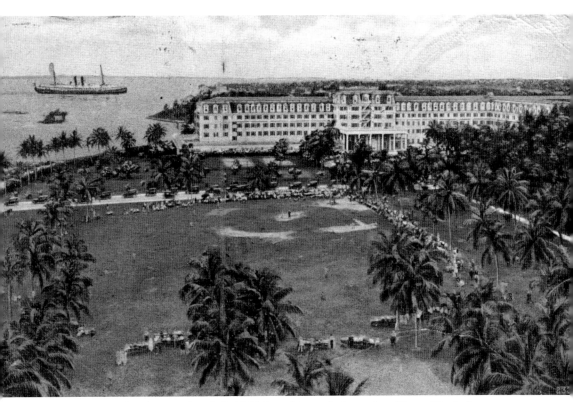

The *c.* 1915 Royal Palm Hotel and Golf Club in Miami belonged to Henry Flagler's company. The course was designed by Alexander Findlay, the "golfer-in-chief" of the Florida East Coast Railway Company. (Courtesy of Historical Association of Southern Florida.)

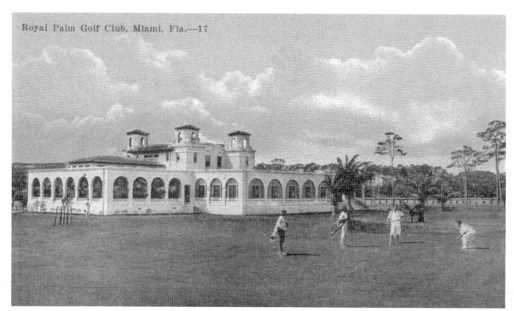

The Royal Palm Golf Club house was separate from the hotel and featured four towers that marked the main room and entry hall. The arched windows and tile roof were in keeping with the prevailing Mediterranean Revival style of the 1920s. (Courtesy of the Moorhead Collection.)

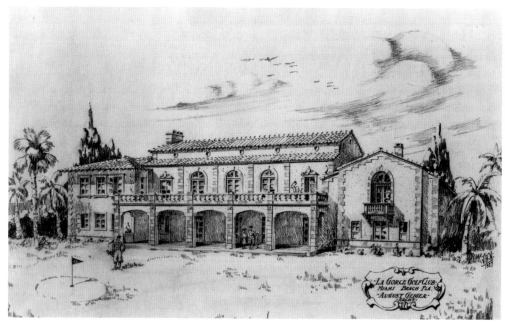

In 1924, Miami Beach architect August Geiger designed the La Gorce Country Club, which was completed in 1927. The club proved to be extremely popular with celebrities of the 1920s, and such luminaries as Jack Dempsey, Gene Tunney, Will Rogers, and Babe Zaharias played the course. The 1928 Miami Beach–La Gorce Open was played here, and Johnny Farrell took the honors. (Courtesy of Historical Association of Southern Florida.)

Stylishly dressed golfers are not affected by Florida's sunshine or heat as they finish a round at an unidentified course in Miami. (Courtesy of Historical Association of Southern Florida.)

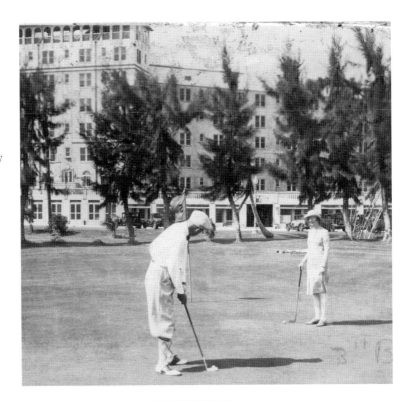

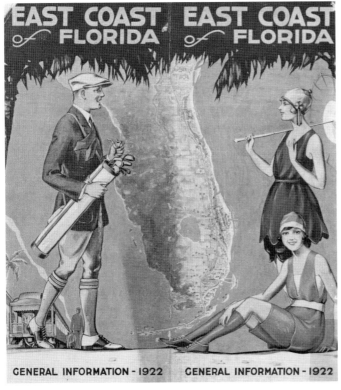

GENERAL INFORMATION - 1922 GENERAL INFORMATION - 1922

Railroad companies, land promoters, and real estate companies spent millions of dollars on colorful brochures and pamphlets that were sent to potential customers in the northern states. (Courtesy of the Florida Historical Society.)

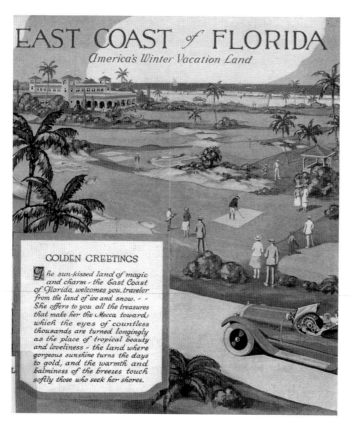

Florida was depicted as a land of perpetual play in the advertising brochures of the 1920s. (Courtesy of the Florida Historical Society.)

Sheep were used to keep the greens and fairways in good shape at some golf courses in the early 1920s. This herd grazes the fourth green at the Winter Park Country Club in 1920. (Courtesy of the Moorhead Collection.)

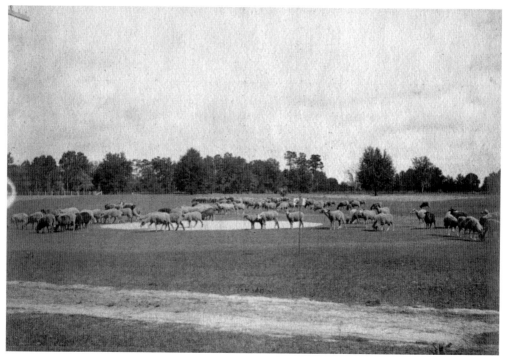

LOCAL RULES

In or over all streets parallel to fairways or on private property, out-of-bounds; penalty loss of distance only. Ball in streets crossing fairways or back of greens, drop back without penalty (optional). Ball lying in bounds within clubs-length of hydrants, buildings or street curbs may be moved to full clubs-length not nearer hole.

On Hole No. 3 ball in first two rows of orange trees along left or right sides of fairways shall be dropped out on fairway not nearer hole without penalty; beyond third row of trees, drop out with one stroke penalty.

Please replace turf; smooth out tracks in sand-traps; do not practice on greens if other players are behind.

The rules of the U. S. G. A. will govern all play except where modified by local rules.

Because many Florida courses were either built in congested residential areas or near orange groves, each club posted special rules for coping with these hazards. (Courtesy of the Moorhead Collection.)

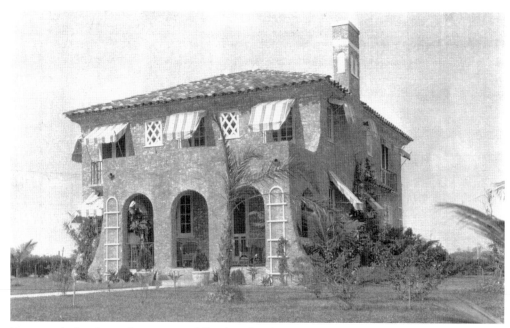

From single-family residences in middle-class developments to palatial palaces along the shores and surrounding golf courses, Mediterranean Revival architecture became the trademark of the Sunshine State in the 1920s. This modest home, designed by Rockledge architect Richard Rummell, cost about $9,000 new in 1925. It featured high ceilings, wooden floors, and a single bathroom with tiled walls, a bathtub-shower, and a single vanity sink, in addition to the porcelain commode. Today these houses are always at the top of the real estate market as new Florida residents seek to recapture the magic of the 1920s. (Courtesy of the Florida Historical Society.)

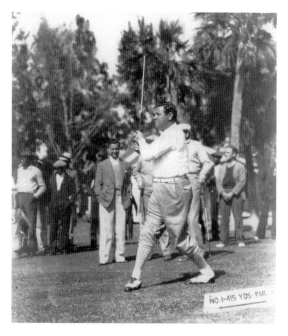

The ever-popular Babe Ruth tees off at the first hole of the Bobby Jones Golf Complex in Sarasota in the mid-1920s. (Courtesy of the Moorhead Collection.)

THE BOOM AND THE BUST: 1920–1940

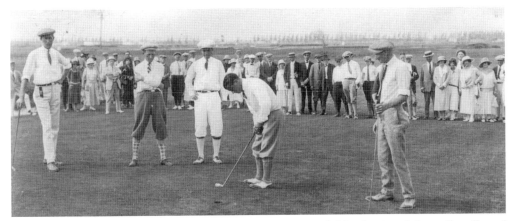

Gene Sarazen putts while, from left to right, Jim Barnes, Jock Hutchinson, Johnny Farrell, and Lee Nelson watch. The course was the Hollywood Golf and Country Club course, and the time was the early 1930s. (Courtesy of the Historical Association of Southern Florida.)

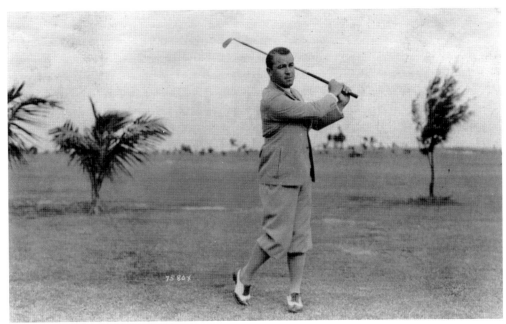

Gene Sarazen poses for this publicity shot in 1927. Sarazen was among the most popular professionals to play the courses around Miami. (Courtesy of the Historical Association of Southern Florida.)

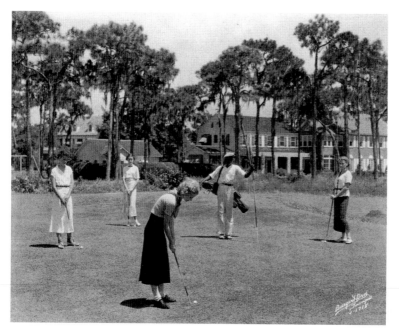

A group of young ladies finishes a hole at the exclusive Palma Ceia Golf Club course in Tampa in 1936. This was another course designed by Tom Bendelow. (Courtesy of the Burgert Brothers Collection, Tampa-Hillsborough Public Library.)

The La Gorce Country Club course is shown here under construction in 1928. La Gorce has become known as one of the most exclusive clubs in the world. (Courtesy of the Historical Association of Southern Florida.)

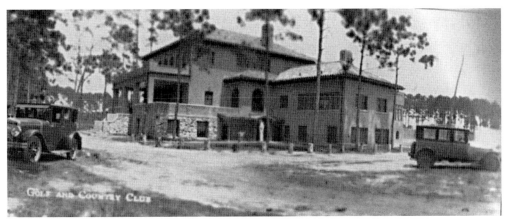

The Daytona Beach Golf and Country Club, designed by Donald J. Ross, was an imposing Mediterranean Revival structure set in the midst of pine trees when it was completed in 1927. (Courtesy of the Moorhead Collection.)

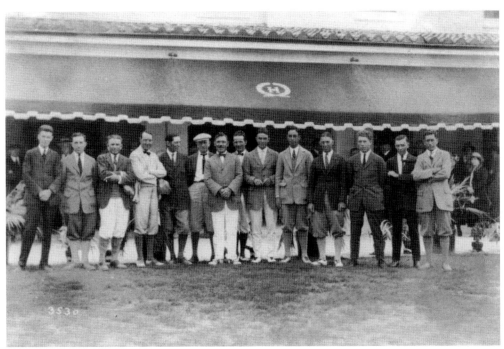

The participants in a golf tournament at the Hollywood Golf and Country Club in Miami in 1923 pose before the tournament opens. (Courtesy of the Historical Association of Southern Florida.)

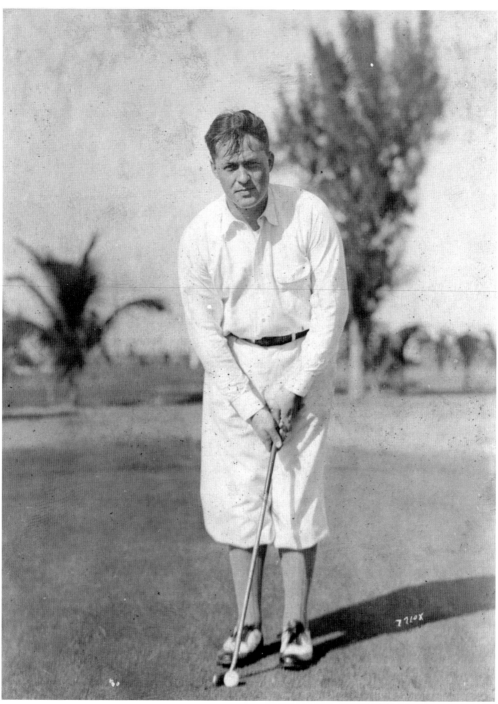

Perhaps no one was more famous as a golfer than Robert Tyre Jones, better known as "Bobby" Jones, during the first two decades of the 20th century. Although he retained his amateur standing throughout his career, Jones played and bettered some of the leading professionals of the era. (Courtesy of the Historical Association of Southern Florida.)

THE BOOM AND THE BUST: 1920–1940

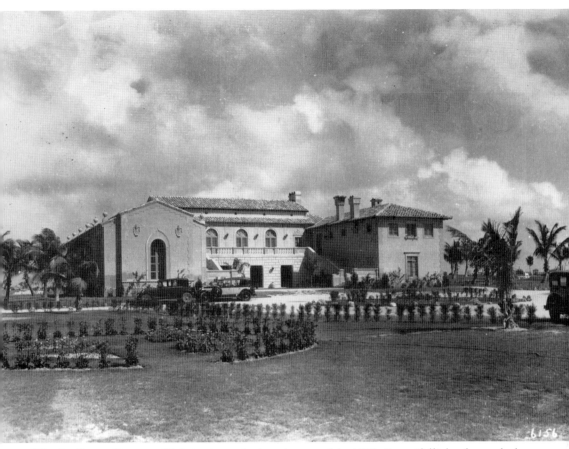

The La Gorce Country Club is pictured when it opened in 1928. Beautifully landscaped, the clubhouse featured an Italianate style of architecture that marked a departure from the more traditional Mediterranean Revival of the early 1920s. (Courtesy of the Historical Association of Southern Florida.)

The La Gorce Country Club was as ornate on the inside as it was on the outside. Members could truly feel protected against the horrible effects of the land bust that swirled around them. Just as the La Gorce course was opening, many courses in the Sunshine State were closing or being transferred to municipal ownership. (Courtesy of the Historical Association of Southern Florida.)

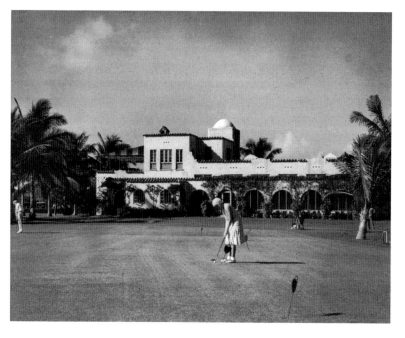

The La Gorce Country Club is seen from the rear. The large practice putting green offered members a great opportunity to sharpen their skills before going onto the course. (Courtesy of the Historical Association of Southern Florida.)

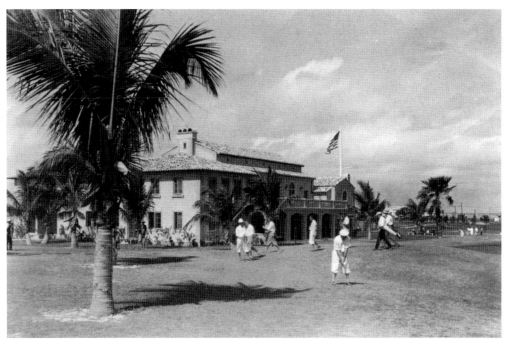

The La Gorce course became an instant success with golfers when it opened in 1928. Despite the economic downturn occasioned by collapse of the Florida land boom, these golfers appear to be free of any worries. (Courtesy of the Historical Association of Southern Florida.)

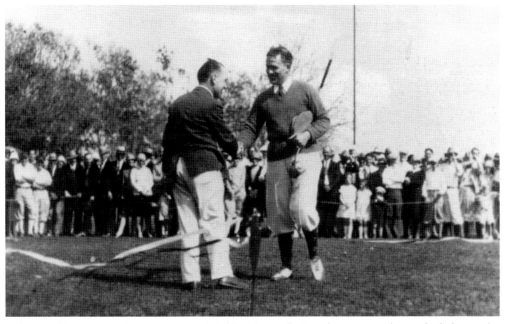

A large gallery cheers for Robert Tyre "Bobby" Jones during the inaugural round of play at the Bobby Jones Golf Complex in Sarasota in 1927. The Bobby Jones course was operated as a municipal course by the City of Sarasota. (Courtesy of the Moorhead Collection.)

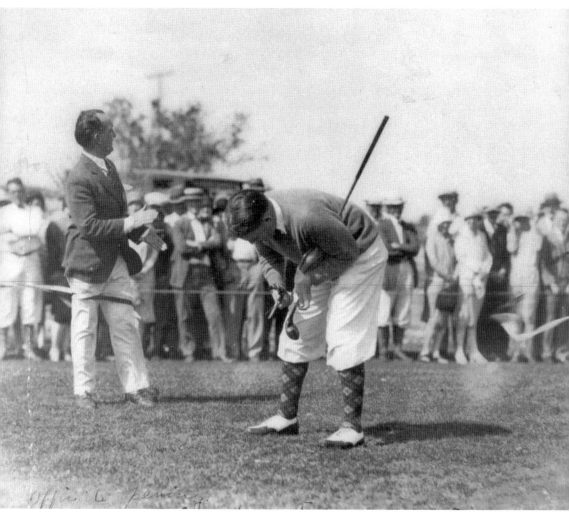

Bobby Jones prepares to tee off during the inaugural round of golf at the Bobby Jones Golf Complex in Sarasota in 1927. This was considered a fitting tribute to Jones after he won both the U.S. Open and British Open in 1926. Although Jones was not a native of Florida or Sarasota, he accepted the honor of having the facility named for him, despite the protests of some locals who thought that any municipal course should be named in honor of J. Hamilton Gillespie. This slight to the "father of Florida golf" was rectified in 1977 when a third golf course, a par-three executive layout, was built in the complex and names in Gillespie's honor. (Courtesy of the Moorhead Collection.)

The clubhouse on Carl Fisher's Miami Beach course is featured on this 1924 postcard. The winds that came off the Atlantic Ocean (notice the bending palm trees) presented golfers with unseen hazards that changed from hole to hole and minute to minute. (Courtesy of the Moorhead Collection.)

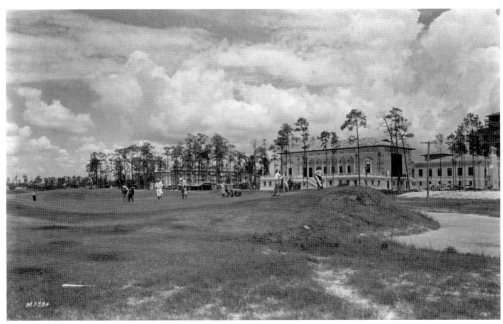

Created in 1924 by noted airplane designer Glen Curtiss, Miami Springs was built adjacent to the Miami airport where Curtiss had a flying school. Golfers enjoy the course before the buildings are completed. (Courtesy of the Historical Association of Southern Florida.)

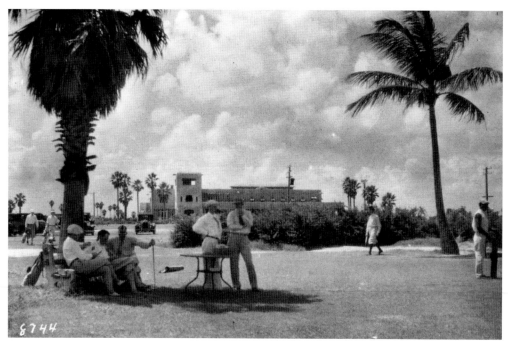

A group of golfers awaits their tee time under the welcomed shade of a palm tree in Miami during the mid-1920s. (Courtesy of the Historical Association of Southern Florida.)

Abe Mitchell (left) poses with a group of golfers for the opening of the 1925 Miami Open, which was played at the Miami Beach Country Club. Carl G. Fisher, the developer of Miami Beach, is standing second from the right. Willie Klein won the tournament. (Courtesy of the Historical Association of Southern Florida.)

The Miami Beach Country Club house is on the banks of the Collins Canal. Carl Fisher's development of Miami Beach was the nucleus of the revival of Miami–Dade County in the 1980s, when the art deco hotels of South Beach became the locale for much of the television program *Miami Vice*. (Courtesy of the Historical Association of Southern Florida.)

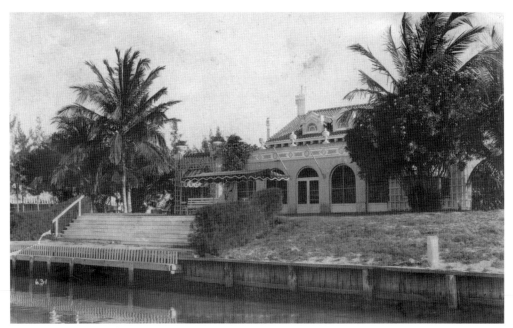

Here is another view of the Miami Beach Country Club on the banks of the Collins Canal. Carl G. Fisher, who developed the town, was worth $100 million in 1927, largely because of sales of homes in the Miami Beach community. By 1930, he was penniless because of the bust that hit the Florida economy in 1928 and because he had invested unwisely in the stock market. (Courtesy of the Historical Association of Southern Florida.)

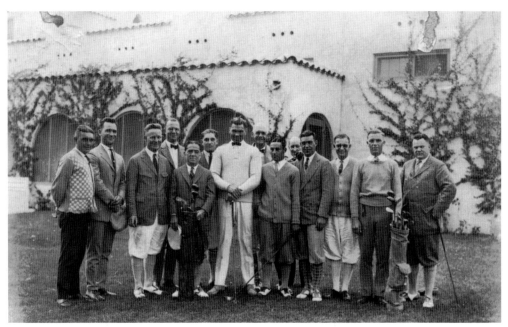

Jack Dempsey is surrounded by admirers at a golf tournament at the Coral Gables Country Club in Miami around 1925. (Courtesy of the Historical Association of Southern Florida.)

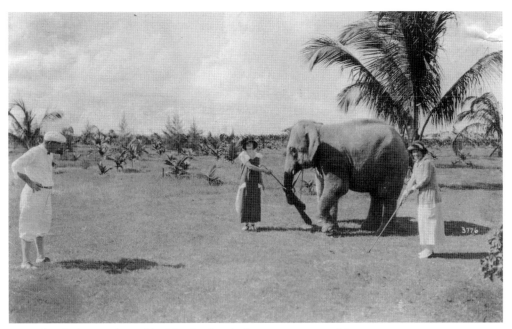

Rosie the elephant, who caddied for this lovely duo, was just one of the many outrageous promotions used to attract potential home buyers to the golf courses of South Florida. (Courtesy of the Historical Association of Southern Florida.)

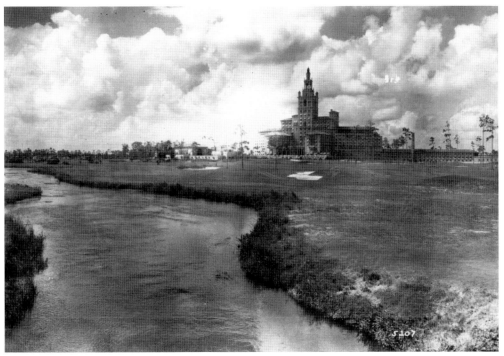

This meandering stream ran through the 36-hole golf complex at the Miami Biltmore Hotel in 1926. (Courtesy of the Historical Association of Southern Florida.)

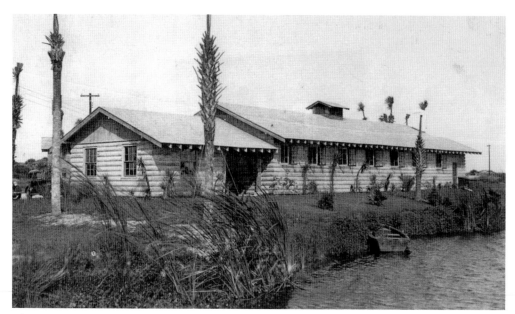

This picturesque log cabin served as the men's locker room and clubhouse during the 1930s and 1940s at the Ponte Vedra Inn and Club. Its close proximity to the Atlantic Ocean (notice the sand dunes in the extreme right foreground) made it difficult to play every hole the same way during every round. The winds from the ocean varied in their intensity and direction, and a skilled golfer would take note of this and apply "Kentucky windage" for his shot. (Courtesy of the Beaches Area Historical Society.)

Although Bobby Jones was adamant about maintaining his status as an amateur, he often received gifts for playing in tournaments. When the Bobby Jones Municipal Golf Complex was opened in Sarasota in 1927, he was given a brand new Pierce-Arrow automobile for playing the first round during opening ceremonies. (Courtesy of the Moorhead Collection.)

4

HARD TIMES, A MAJOR

WAR, AND RECOVERY

1940–1950

The twin disasters of hurricanes in 1926 and 1928 and the collapse of the stock market in 1929 spelled the end of the Florida real estate boom. Spread throughout the Sunshine State, unfinished subdivisions complete with paved streets, streetlights, and driveways sat forlornly in the scorching heat of summer, silently waiting for eager buyers who never came. Real estate moguls whose wealth was counted in the tens of millions just two years earlier were humming the words to the popular song of the era, "Brother, Can You Spare a Dime?" Paper millionaires became paper paupers overnight. For some, the end of the land boom in the Sunshine State became the end of their dreams of wealth and fame, and they simply faded back into obscurity. Some, like D. P. "Doc" Davis, went out in style, but they went out nevertheless. Davis, whose Davis Islands development had symbolized the possibilities of the boom on the west coast of Florida, boarded a transatlantic cruise ship with his 12-year-old son and his mistress. Somewhere in the vast expanse of the Atlantic, Davis disappeared forever. Did he throw himself overboard to escape his cascading debts? Or, as some speculated, did he meet a fast speedboat in mid-ocean and make his way to Mexico where, some sources reported, he had squirreled away an $11-million fortune? His mistress arrived in France with the young boy in tow, showed him the sights of the city, and then disappeared into obscurity. Others, like D. Collins Gillett, the developer of Temple Terrace, remained in public view with severely depleted incomes. Carl G. Fisher, the developer of Miami Beach, saw his fortune go from $100 million in 1927 to $0 in 1929.

Whatever their status at the end of the 1920s, these men could take great pride in what they had created. Florida was changed forever. From a somnambulant rural backwater in the early 1900s to the destination of choice for people from around the world by 1926, the Sunshine State, though damaged by economic collapse and natural catastrophes, was inextricably linked to the image of sun, fun, beaches, and golf. This was the reality that was—and still is— its raison d'être. The same men who marketed their visions of real estate development created the process by which developers of the post–World War II era marketed the revived Florida. Hundreds of chambers of commerce and economic development groups spend millions of dollars today proving there is nothing new under the sun as they steal the language and layouts of advertisements created during the 1920s. Only the media outlets and technology have changed; the message remains the same.

What about golf after the bust? Some new courses were built, but these were primarily for the super-wealthy whose fortunes, while diminished, were never in danger of disappearing. The La Gorce Country Club on Biscayne Bay, built in 1927, continued to operate unhindered by the Depression.

Some courses changed hands, moving out of proprietary ownership into the hands of groups whose members, while not able to afford the costs of operating a course individually, kept them in operation through membership dues and green fees. Some courses were transferred to municipal ownership, but most of these transfers were transitional at best, since the shrinking tax rolls produced less and less income. Cash-strapped and unable to maintain some basic services, cities and towns were reluctant to take on the additional expense of maintaining and operating golf courses. Some courses never made it past the architect's drawings, mute testimony to what might have been. Finally, some courses lay fallow in the Florida sun, gradually giving way to the onslaught of palm trees, palmetto bushes, and scrub oaks—reclaimed by the very environment from which they had been carved.

By the end of the 1930s, however, the American economy began improving. The "make work" programs of the New Deal and the demands for armaments by warring European powers infused more and more money into the economy. By the time the United States entered World War II in 1941, a growing confidence had returned, and Americans felt freer than they had in 10 years that they could afford to spend some of their wages on recreation. In the Sunshine State, the large hotels and country clubs of the 1920s were appropriated by the federal government for use as training facilities and hospitals for American troops. Miami Beach hotels were used to house officers in training. Publicity shots of Clark Gable and other movie stars marching along the beach renewed interest in Florida. Later in the war, the Don Cesar, the Vinoy, the Belleview, and other luxury hotels on Florida's west coast were converted into hospitals. All in all, some two millions servicemen trained at the 60 or so bases that were established in the state. Many of these bases are still active today.

Authorities were hard-pressed to find recreational activities for the troops stationed here. As they cast about for opportunities, they naturally focused on the hundreds of golf courses that were in use or vacant in close proximity to the bases. Arrangements were made to use them, either as wholly run military facilities or through agreements that allowed troops to have membership privileges at country clubs. The more exclusive country clubs were usually willing to accept only officers—they had been declared gentlemen by their commissions—and clear lines of class and status were maintained. Municipal courses or those belonging to an appropriated hotel were generally opened to all ranks.

Not only did the war effort revive Florida's economy, but the war had an even longer lasting effect on the servicemen who came to the Sunshine State. Many took home fond memories of their time in Florida, and when the war was over, they were eager to bring their families with them to visit the state. The number of tourists coming to the Sunshine State—some 80 million in 2000—increased dramatically each year from 1946 until 2007, when another bust in the real estate market occurred.

The war years and the immediate aftermath renewed interest in Florida real estate. As the war generation started to retire in the late 1950s and early 1960s, hundreds of thousands decided to do so in Florida. Although new building designs and new technology, such as air-conditioning and mosquito spraying, changed the looks of postwar developments, they owed their existence to the plans of the pioneers of the 1920s. Indeed, many of these communities were built on the original plans of long-forgotten developers.

From a permanent population of 1.5 million in 1950, the state reached an all time high of 18.5 million in 2005. Golfers make up a significant percentage of this large increase in the number of residents. In 1930, there were approximately 200 golf courses in the state of Florida. Today there are roughly 1,400 courses, and more are under construction. Where the game goes from here is anybody's guess.

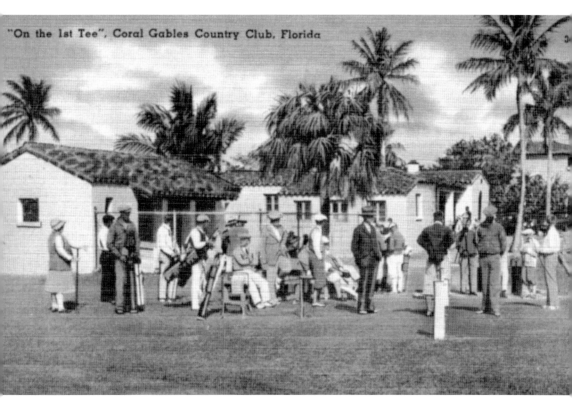

"On the 1st Tee", Coral Gables Country Club, Florida

Recuperating soldiers from World War II took advantage of the locations of service hospitals in major Florida hotels to learn and play golf. This 1946 postcard from Pfc. Ted Davison, a patient at the hospital in Coral Gables, who sent it to his father, referred to the Coral Gables Country Club as "pretty snazzy." (Courtesy of the Moorhead Collection.)

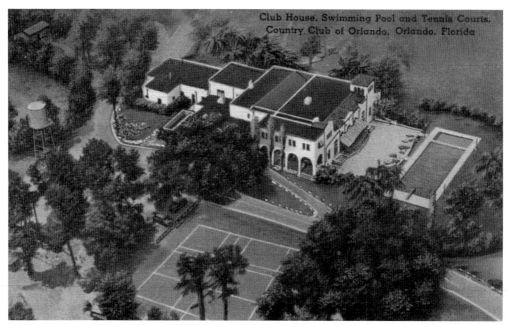

The Country Club of Orlando was one of the favorite hangouts for officers from the nearby air base and naval training facility in Orlando during World War II. Officers received full membership benefits at the club. (Courtesy of the Moorhead Collection.)

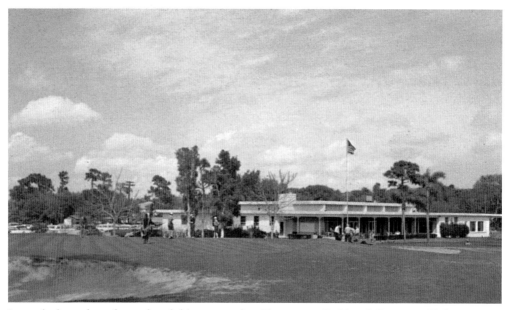

Low, sleek, and modern, the clubhouse at the Clearwater Golf and Country Club caters to permanent area residents and winter visitors. The architectural style of the post–World War II golf clubs featured clean lines, low profiles, and air-conditioning (note the unit on top of the club house), which allowed for lower operating costs and more efficient cooling and embodied the postwar break with the traditions of the past. (Courtesy of the Moorhead Collection.)

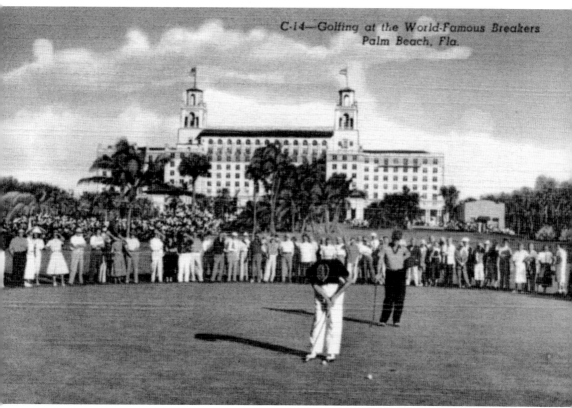

Although there was a significant change in the outward appearance of country clubs built after World War II, the older and more established clubs still attracted large numbers of golfers. A large gallery watches a pair of unidentified players in this mid-1950s tournament held at The Breakers in Palm Beach. Even today, some of the more famous courses from the late 1800s and early 1900s are the preferred venues for some tournaments. (Courtesy of the Moorhead Collection.)

GOLF IN FLORIDA: 1886–1950

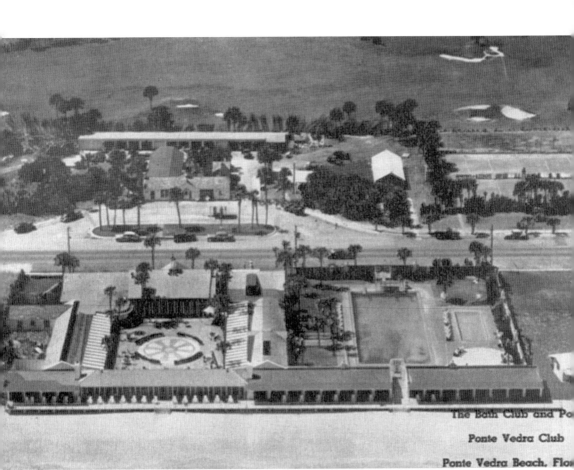

The Bath Club and Po...

Ponte Vedra Club

Ponte Vedra Beach, Flo...

The Ponte Vedra Inn and Club, with a history stretching back to the first decade of the 20th century, has been modernized over the years. Today it incorporates a massive swimming pool and tennis courts, along with its two premium golf courses, into its overall operations. Several well-known professional golfers, such as Jim Furyk, Fred Funk, and Vijay Singh, own houses in Ponte Vedra Beach and consider it to be their home course. (Courtesy of the Moorhead Collection.)

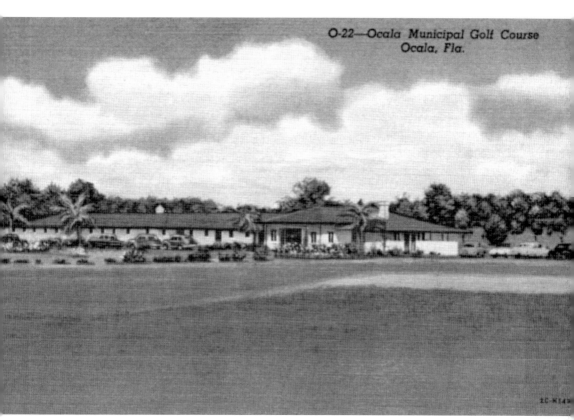

The Ocala Municipal Golf Course closely resembles the popular post–World War II ranch style of architecture that became synonymous with the "new" Florida of the 1950s. (Courtesy of the Moorhead Collection.)

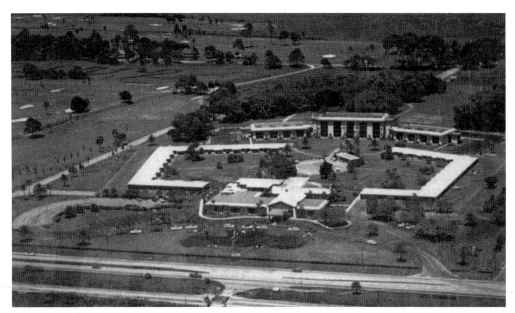

The St. Augustine Links Golf Course, also known as Ponce De Leon Golf and Conference Resort, had an 18-hole course designed by Donald J. Ross built in 1916. The course, built by Flagler's East Coast Railway Company and frequented by Pres. Warren G. Harding in the 1920s, endured until 2003. Harding selected his cabinet while golfing in St. Augustine. In the late 1990s and into the early part of this century, the number of golf rounds became so low that it was not economically feasible to keep the golf facility open. The golf course and resort were sold to a developer in 2003. The grounds will soon become home to another northeast Florida housing subdivision. (Courtesy of the Moorhead Collection.)

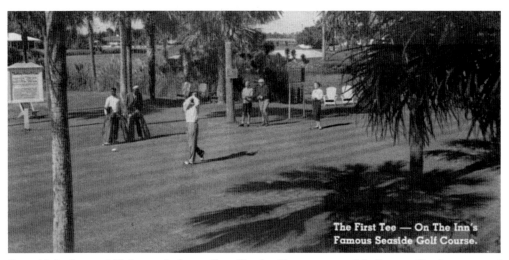

The First Tee — On The Inn's Famous Seaside Golf Course.

Ponte Vedra Inn and Club, near Jacksonville, offered golfers a variety of challenges. On the reverse of this 1950s postcard, Jane, the writer, was so impressed with this course and the ones at Fort Lauderdale and Vero Beach that she declared, "We're ready to move here!!" Golf was once again working its magic in attracting new residents to the Sunshine State. (Courtesy of the Moorhead Collection.)

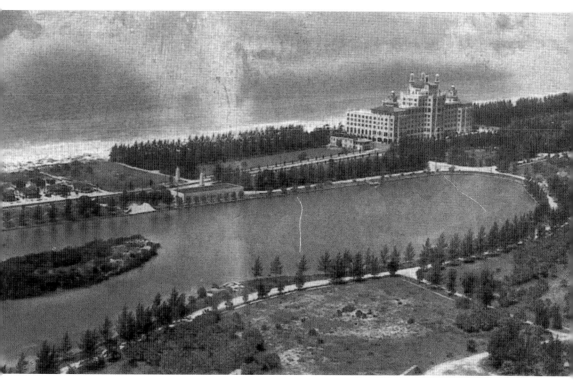

The Don Cesar resort featured an outstanding luxury environment for many pre–World War II golfers who played nearby courses. During the war, the resort was appropriated by the military and used as a hospital for servicemen recuperating from wounds or from battle fatigue. The same nearby courses that were so popular with tourists of the prewar period were utilized as recreational outlets for them. The Don Cesar remains a popular resort today, and thousands of people stay there each year. (Courtesy of the Moorhead Collection.)

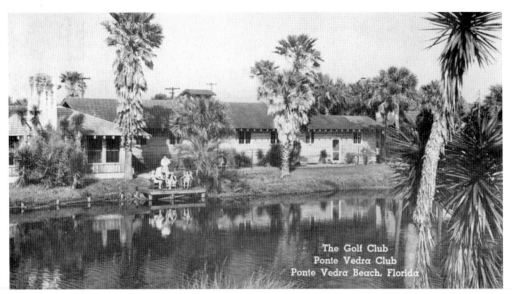

The Golf Club
Ponte Vedra Club
Ponte Vedra Beach, Florida

Despite its continual renewal, the Ponte Vedra Club has a healthy respect for its history, and the members of the club attempt to utilize as many of the older buildings as possible at the facility. The club of today, however, is vastly different from the club of yesterday. This photograph captures the laid-back lifestyle of the early 1950s. (Courtesy of the Moorhead Collection.)

BOBBY JONES GOLF COURSE, SARASOTA, FLORIDA—K9

The Bobby Jones Golf Complex in Sarasota offers a challenging course to golfers who can play in the hot sun and still find a shady respite under the trees, a wide variety of which grow profusely on the course. This postcard picture dates from the early 1950s. There have been many new improvements to the course since then, and a third venue, an executive course named for J. Hamilton Gillespie, opened in 1977. (Courtesy of the Moorhead Collection.)

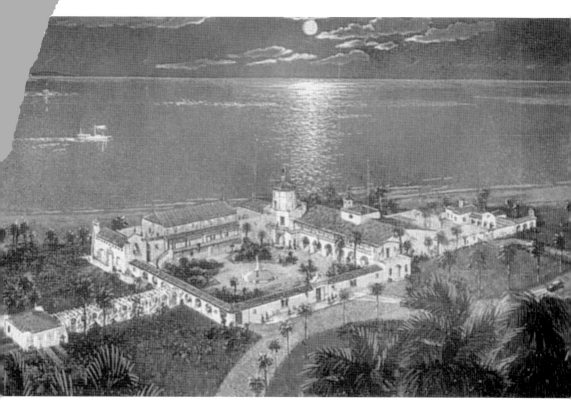

The Pasadena Golf and Country Club is another 1920s favorite that has survived into the 21st century. "Sir" Walter Hagen had been a consultant in the original design of the Pasadena course, which was the venue for the most publicized one-on-one tournament held in Florida in 1926. Hagen and Bobby Jones agreed to play a 72-hole match. The first 36 holes were played on Jones's home course at Whitfield Estates, and the last 36 were played at the Pasadena course, which was Hagen's home course. Hagen won the match by a 72-hole score of 12-11. (Courtesy of the Moorhead Collection.)

ACROSS AMERICA, PEOPLE ARE DISCOVERING SOMETHING WONDERFUL. *THEIR HERITAGE.*

Arcadia Publishing is the leading local history publisher in the United States. With more than 4,000 titles in print and hundreds of new titles released every year, Arcadia has extensive specialized experience chronicling the history of communities and celebrating America's hidden stories, bringing to life the people, places, and events from the past. To discover the history of other communities across the nation, please visit:

www.arcadiapublishing.com

Customized search tools allow you to find regional history books about the town where you grew up, the cities where your friends and family live, the town where your parents met, or even that retirement spot you've been dreaming about.